LEONARDO DA VINCI

THE ANATOMY OF MAN

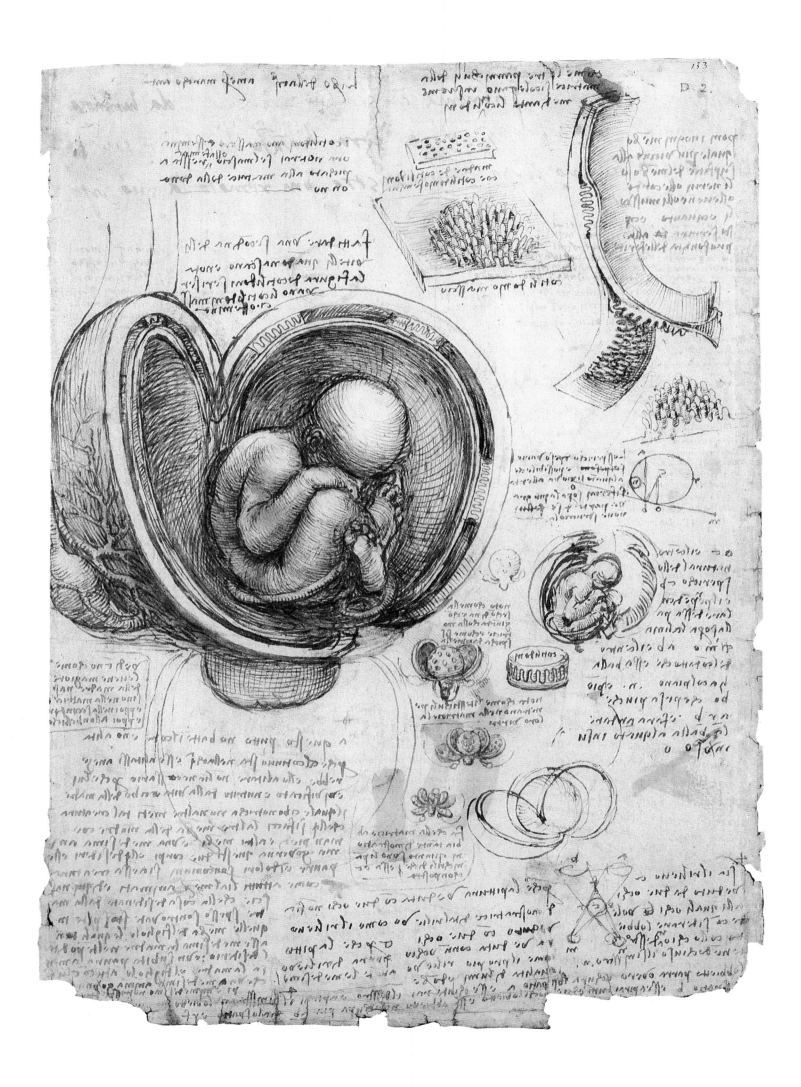

LEONARDO DA VINCI

THE ANATOMY OF MAN

*Drawings from the Collection
of Her Majesty
Queen Elizabeth II*

BY MARTIN CLAYTON

WITH COMMENTARIES ON ANATOMY
BY RON PHILO

THE MUSEUM OF FINE ARTS, HOUSTON

A BULFINCH PRESS BOOK
LITTLE, BROWN AND COMPANY
BOSTON · TORONTO · LONDON

Published on the occasion of the exhibition
Leonardo da Vinci: The Anatomy of Man. Drawings from the Collection of Her Majesty Queen Elizabeth II

Organized by The Royal Library at Windsor Castle in conjunction with the Museum of Fine Arts, Houston.

This exhibition is made possible by Conoco Inc., a Du Pont company
Union Texas Petroleum
Mr. and Mrs. Edward Gregg Wallace, Jr.

The Museum of Fine Arts, Houston
June 28, 1992–September 6, 1992

The Philadelphia Museum of Art
September 19, 1992–November 19, 1992

The Museum of Fine Arts, Boston
December 11, 1992–February 21, 1993

First Edition

Library of Congress Cataloging-in-Publication Data
Clayton, Martin, 1967–
 Leonardo da Vinci : the anatomy of man : drawings from the collection of Her Majesty Queen Elizabeth II / essay and catalogue by Martin Clayton : with commentaries on anatomy by Ron Philo.
 p. cm.
 Published on the occasion of an exhibition organized by the Museum of Fine Arts, Houston, June 28–Sept. 6, 1992.
 Drawings and prints from the Royal Library, Windsor Castle, and other institutions.
 Includes bibliographical references.
 ''A Bulfinch Press Book''
 ISBN 0-8212-1916-2
 1. Leonardo, da Vinci, 1452–1519—Exhibitions. 2. Anatomy, Artistic—Exhibitions. 3. Elizabeth, II, Queen of Great Britain, 1926– —Art collections—Exhibitions. 4. Drawing—Private collections—England—Windsor (Berkshire)—Exhibitions. 5. Windsor Castle. Royal Library—Exhibitions. I. Leonardo, da Vinci, 1452–1519. II. Philo, Ronald. III. Museum of Fine Arts, Houston. IV. Windsor Castle. Royal Library. V. Title.
NC257.L4A4 1992
741.945—dc20 91-37933

Published by the Museum of Fine Arts, Houston, and Bulfinch Press
Bulfinch Press is an imprint and trademark of Little, Brown and Company (Inc.)
Published simultaneously in Canada by Little, Brown & Company (Canada) Limited

PRINTED IN HONG KONG

CONTENTS

FOREWORD 6
 Oliver Everett

ACKNOWLEDGMENTS 8
 Peter C. Marzio

LEONARDO THE ANATOMIST 11
 Martin Clayton

CATALOGUE OF THE EXHIBITION 25
 Martin Clayton and Ron Philo

CONCORDANCES 139

A NOTE ON LEONARDO'S MANUSCRIPTS 140

ABBREVIATIONS AND SELECTED
BIBLIOGRAPHY 141

FOREWORD

HER MAJESTY THE QUEEN possesses, in the Royal Library at Windsor Castle, more than six hundred drawings by Leonardo da Vinci, the finest such collection in the world. These drawings cover the wide spectrum of Leonardo's amazing talents and interests. Of all the men of genius who played a part in the Italian Renaissance, none is more remarkable than Leonardo. Master of any discipline to which he set his hand—painting, sculpture, architecture, anatomical dissection, engineering, and music— he exemplified the spirit of enquiry about nature to which the vast corpus of modern scientific knowledge owes its origin.

On Leonardo's death in 1519, the contents of his studio, which included several thousand drawings, passed to his favorite pupil, Francesco Melzi, whose handwriting may be seen on cat. 22b in the present exhibition. After Melzi's death (about 1570) most of the collection was bought by the sculptor Pompeo Leoni, who rearranged the folios and bound them into volumes. Leoni, who was court sculptor to the king of Spain, took some of the volumes to Madrid. On his death in 1609, one volume, containing examples of every field in which Leonardo worked, was acquired and brought to England by the celebrated collector and artistic adviser to King Charles I, Thomas Howard, Earl of Arundel. While it belonged to him, some of its drawings were etched by Wenceslaus Hollar. Howard had to leave the country during the Civil War, and it is uncertain whether or not he took the volume with him.

According to Count Galeazzo Arconati, who gave other Leonardo manuscripts to the Ambrosian Library in Milan, drawings concerning anatomy, nature, and color were "in the hands of the King of England" before 1640. This statement, and the fact that virtually all the surviving anatomical drawings by Leonardo are now in the Royal Collection and formed part of the volume bought by Arundel, suggests that the volume did not leave the country but was acquired by King Charles I. Others have surmised that it may not have reached the Royal Collection until after the restoration of King Charles II, to whom it could well have been sold or presented by Sir Peter Lely, one of the keenest collectors of drawings of his day. By whatever route it reached the Royal Collection, it is recorded for certain as being in the possession of Queen Mary II in 1690, a year after she and her husband, King William III, ascended the English throne as joint monarchs.

This volume contained all the six hundred folios now in the Royal Library, Windsor Castle. During the three centuries that they remained within its covers, those executed in chalk suffered considerably from rubbing. To prevent further damage, most of the single-sided drawings were laid down on separate mounts in the nineteenth and early twentieth centuries. This technique could not, however, be applied to the anatomical series, comprising about two hundred sheets, most of whose folios bear drawings on both sides of the paper. The only solution was to rehouse them in new bindings, which exposed them to the same dangers as before.

In the 1970s the Drawings Restoration team at the Royal Library, headed by Michael Warnes, applied a technique, first to the anatomical drawings, and subsequently to all the other sheets by Leonardo, of encapsulating the drawings between two thin layers of acrylic sheeting containing an ultraviolet filter. This in turn was set into mountboard, thus providing a safe environment for the drawings and enabling both sides of each sheet to be seen.

The anatomical drawings have not been exhibited together since 1984, and the twenty-three sheets that form this exhibition have been selected as prime examples of Leonardo's studies of anatomy. The medical commentary, illuminating the content of each sheet in the light of contemporary knowledge, has been written for the catalogue by Ron Philo, senior lecturer in anatomy at the University of Texas Medical School at Houston.

Although conceived by Leonardo primarily as scientific drawings, they are of course consummate works of art in their own right; we are especially indebted to Martin Clayton, assistant curator in the Print Room at Windsor, for explaining their historical context.

It is most satisfying that this particular exhibition should so appropriately be visiting three cities with outstanding medical centers in the United States. And it has been a great pleasure for us in the Royal Library to work on the exhibition with the Museum of Fine Arts, Houston; the Philadelphia Museum of Art; and the Museum of Fine Arts, Boston.

OLIVER EVERETT
Librarian
Windsor Castle

ACKNOWLEDGMENTS

THIS EXHIBITION and the accompanying catalogue are devoted to the unparalleled studies of human anatomy by Leonardo da Vinci, the towering Renaissance master. Twenty-three of Leonardo's finest sheets, eighteen of them displaying drawings on both sides, present a comprehensive survey of the anatomical drawings preserved at the Royal Library, Windsor Castle—the most important scientific studies of the human body in the history of art.

Leonardo's anatomical drawings reveal him as a gifted observer of the human body in all its parts. He studied not only living men and women, but also the dead, dissecting with painstaking care in order to draw each vessel, muscle, or organ with ultimate precision. These works show the remarkable evolution of the artist's drawing style as well as his changing concern for knowledge of the human form and the physiology of vision. They also demonstrate one fundamental aspect of the Florentine humanist's fascination with all that makes up man—and the Florentine craftsman's appreciation of the complex and beautiful structure of the physical world.

With our colleagues at the Philadelphia Museum of Art and the Museum of Fine Arts, Boston, we are greatly indebted to Her Majesty Queen Elizabeth II for her willingness to share these magnificent drawings with the American people.

The sheets have been selected by Jane Roberts, curator of the Print Room, the Royal Library, Windsor Castle, in consultation with Oliver Everett, librarian, and Martin Clayton, assistant curator. We are grateful to them and to Theresa-Mary Morton, assistant curator, exhibitions, for their friendly cooperation and efficient organization.

The catalogue has been written by Martin Clayton in conjunction with Ron Philo, senior lecturer in anatomy at the University of Texas Medical School at Houston. Mr. Clayton's scholarly essay on Leonardo in the context of the history of anatomy, and his entries on the individual drawings, is paralleled for the first time by commentaries written by a modern anatomist, Dr. Philo, who addresses the issues of Leonardo's accuracy, his unusual gift for rendering complex anatomical structures, and the relevance of his works for the modern student of the human body.

George T. M. Shackelford, curator of European painting and sculpture, and Barry Walker, curator of prints and drawings, coordinated the American organization of the exhibition for the Museum of Fine Arts, Houston. Their colleagues at Philadelphia and Boston, Anne Percy and Clifford Ackley, together with the staffs of the three museums participating in the tour, have contributed their expert efforts to the realization of the exhibition.

A comprehensive exhibition of Leonardo's anatomical drawings is an event of major importance for students of Renaissance art and history. These works have never before been exhibited in Houston, Philadelphia, or Boston. For this reason alone, the exhibition is a landmark in the history of the cities and regions served by the three institutions. Assuring that the works would be properly protected during their tour of the United States, the Federal Council on the Arts and the Humanities has granted an indemnification to the exhibition. We are grateful to the council and to Alice Whelihan, indemnity administrator, for this crucial support. This exhibition has been funded by Conoco Inc., a Du Pont company; Union Texas Petroleum; and Mr. and Mrs. Edward Gregg Wallace, Jr.

To all who have made this exhibition possible, we owe a great debt. The hundreds of thousands of people who will view these brilliant works of art will come away not only with a greater understanding of the history of art and medicine in the Renaissance, but also with a profound sense of the humanity of one of its greatest men.

PETER C. MARZIO
Director
The Museum of Fine Arts, Houston

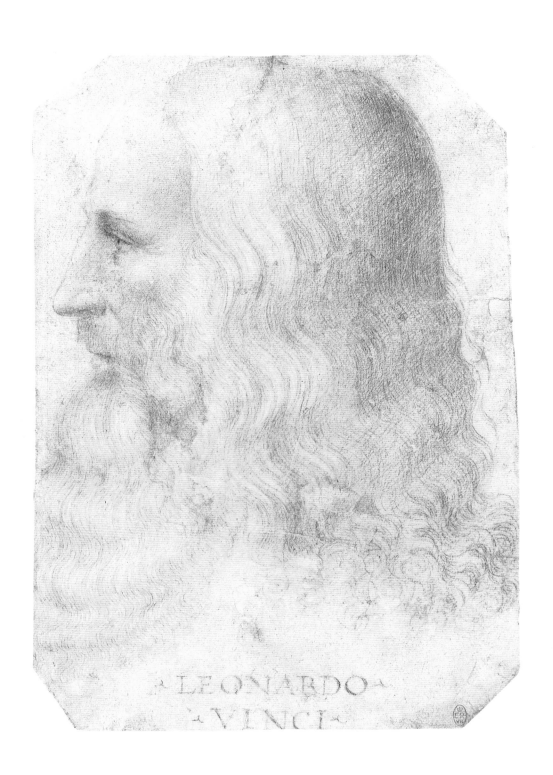

·LEONARDO·
·VINCI·

LEONARDO THE ANATOMIST

MARTIN CLAYTON

LEONARDO DA VINCI WAS ONE of the pivotal figures in the development of Western art, recognized since his death as the father of the High Renaissance. Remarkably, he was also one of the most original and perceptive anatomists of his own or any other time, and yet a history of European anatomical knowledge may legitimately be written without once mentioning his name.

Whereas his paintings were widely known, and copies disseminated all over Italy and beyond, only a few friends and associates had any intimation of the extent of his medical researches. He never worked as a professional anatomist, he never taught the subject, and most importantly, he never published any of his discoveries. Seldom can a scientist have made so many advances while changing the course of his chosen subject so little.

It is thus possible to view Leonardo's researches as an isolated phenomenon, splendid or tragic, depending on one's sense of romanticism. Although the historian must always beware of artificial periodization, Leonardo's researches can, I believe, be divided into three distinct phases. The first phase is isolated from the second by a gap of some ten years, in which Leonardo was, seemingly, inactive as an anatomist; the second is separated from the third by a friendship with a professional anatomist, which was to transform fundamentally Leonardo's working methods. The complex of medieval tradition from which he sprang determined, initially, his concerns and methods, and this must be considered at every turn. But beyond that, his twenty-five-year anatomical career is a model of autodidacticism, proclaiming just how great the observational powers and intellectual capabilities of a single human being can be.

ART AND ANATOMY IN THE FIFTEENTH CENTURY

In the first theoretical treatise of the Renaissance, Leon Battista Alberti's *On Painting* of 1435, the artist was instructed "first to sketch in the bones, for, as they bend very little indeed, they always occupy a certain determined position. Then add the sinews and muscles, and finally clothe the bones and muscles with flesh and skin."[1] Paradoxically, this became such a cliché of theory that seldom do we find a painter diligently following the procedure in practice; Raphael's study (1507, fig. 1) for the Borghese *Entombment* is a rare example. Nonetheless, an emphasis on structural accuracy was a major feature of all fifteenth-century theory: the components of a painting should be constructed and deployed according to

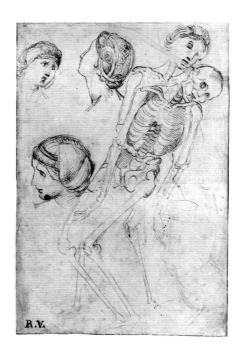

Fig. 1
Raphael, *Study for the Borghese Entomb-ment*. Pen and ink over black chalk. London, British Museum (1895-9-15-617).

objective, even scientific, principles, and thus the depiction of the human body demanded knowledge of its morphology.

Our knowledge of how artists acquired such anatomical familiarity is meager. Giorgio Vasari claimed in his biography of Antonio Pollaiuolo, published in 1568, that the artist had "flayed many bodies, to see the anatomy beneath,"[2] and Pollaiuolo's famous engraving of the *Battle of Ten Nude Men* (c. 1475, fig. 2) is often cited as evidence of this activity. But upon inspection, the anatomy of these figures shows significant errors, both of commission and omission. Nothing in Pollaiuolo's oeuvre indicates his personal participation in a dissection, and one is left with the overriding impression of a mere acquaintance with the appearance of a flayed body, brought to bear on a superficial study of the living form.

In this light, much may be read into the words of the great Florentine sculptor Lorenzo Ghiberti, in his *First Commentary* written about 1450: "It is necessary . . . to have seen dissections, in order that the sculptor, wishing to compose the *statua virile*, knows how many bones are in the human body, and in a like manner knows the muscles and all the tendons [*nervi*] and their connections."[3] The point to note is that artists were to have seen, not performed, dissections.

Such public dissections were performed periodically by the medical schools of the universities. Their regular teaching practice is illuminated by a request by the University of Tübingen to Pope Sixtus IV for "permission to take the bodies of legally executed criminals from the place of execution, and to dissect them according to medical rules and practice without any special license from the Holy See."[4] This request was granted in 1482, "provided the dissected bodies be given burial." Ten years later, the procedure at Tübingen was laid down: "The professor . . . shall read from the writings of the Doctors, especially Mondino, about the part of the body to be demonstrated. After discussion, each organ shall be shown plainly for inspection." Such an exercise in orthodoxy was the subject of an illustration in a contemporary Venetian medical compendium (fig. 3).

Mondino de' Luzzi was professor of anatomy at the University of Bologna in the early fourteenth century. The medical school there was an outgrowth of the law faculty, and existed partly to perform post-mortems.

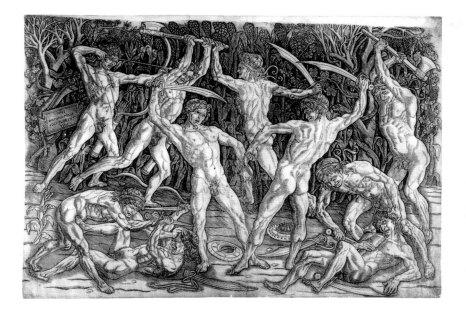

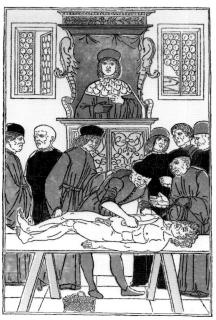

Fig. 2
Antonio Pollaiuolo, *Battle of Ten Nude Men*. Engraving. London, British Museum.

Fig. 3
Unidentified Venetian artist, *Dissection scene*. Woodcut. From Johannes de Ketham, *Fasciculo de Medicina* (Venice, 1494).

Mondino's consequent experience of human dissection, part of the first revival of this theologically delicate practice since before Roman times, was transmitted in his *Anathomia*, written in 1316 and an invaluable guide to dissection for his followers. Mondino's own sources were the Arabic commentators and translators of the medical texts of Aristotle and Galen, primarily Avicenna, and a general growth of medical activity around 1480 was partly due to the publication of a number of these standard texts in the wake of the printing revolution: the 1470s saw editions of Mondino, of Avicenna's *Canon*, Aristotle's *De Anima*, and Celsus's *De Medicina*, among others. The original works of Galen himself, whose prolific writings in the second century A.D. shaped all subsequent anatomical endeavor, were virtually unknown until the early sixteenth century; this revival, as we shall see, was to change the course of Leonardo's own work.

The level of knowledge contained in the standard works far outstripped the quality of contemporary anatomical illustration. One of the fundamental achievements of the Renaissance was the elevation of painting, sculpture, and architecture to the status of the liberal arts. Before the sixteenth century, most scholars looked down upon visual matters as purely mechanical, not a concern of the intellect, and they strongly resisted the corruption of a text by images. A social and functional gulf existed between the medical tracts and the crude situs-figures of the barber surgeons (see cat. 4), whose practices of bloodletting were more relevant to the populace than were the Latin expositions of the universities.

The revolution in pictorial representation, spreading outwards from Florence in the early fifteenth century, thus had no immediate impact on anatomical illustration. While the artist was primarily interested in superficial detail, as conveyed by a sensitive life-drawing, the anatomist concerned himself with internal system. The union of the two, which held so much promise, could only come about either in a collaboration between a communicative anatomist and a receptive illustrator (as occurred, decisively, between Andreas Vesalius and Jan Stefan van Calcar), or, much less probably, in an individual skilled both as an artist and as an anatomist. Yet these abilities were to be combined, incomparably, in Leonardo da Vinci.

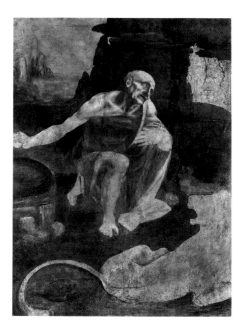

Fig. 4
Leonardo da Vinci, *St. Jerome*. Under-
painting on panel. Vatican City,
Pinacoteca Vaticana.

Fig. 5
Leonardo da Vinci, *Studies of the spinal
cord, leg, and arm*. Metalpoint on blue
prepared paper with ink reinforcement.
Windsor Castle, Royal Library
(RL 12613v).

LEONARDO'S EARLY WORK
c. 1487–1495

Born in 1452, Leonardo was trained in the studio of the Florentine sculptor
and painter Andrea del Verrocchio. Though his most anatomically explicit
work (a restoration of an antique *Flayed Marsyas*, described by Vasari) has
been lost, there is no reason to suppose that Verrocchio's background of
anatomical experience and application was significantly different from that
of contemporaries such as Pollaiuolo. These origins are reflected in the
earliest extant drawings by Leonardo to reveal an anatomical interest.
The combination of surface inspection and the witnessing of dissections
is shown most strikingly in Leonardo's unfinished painting of *St. Jerome*
(c. 1485, fig. 4).

By the time Leonardo started the *St. Jerome*, he had settled in
Milan, having left Florence sometime in late 1481 or 1482. Although it is
easy to overstate the contrast, the intellectual atmosphere of Sforza Milan
was significantly different from that of the speculative Neoplatonism that
prevailed in Medicean Florence. The robust life of the northern university
city supported one of the largest medical centers in Italy, the Ospedale
Maggiore, and a directive of 1480 expressly allowed human dissection at
one of its branches, the Ospedale del Brolo.

However, there is no evidence that Leonardo personally performed
dissections of any kind before about 1487. Faced with such a huge field
of enquiry, it is not surprising that the earliest surviving sheets (fig. 5)
comprise a wide-ranging assortment of images that synthesize elements
of human dissection, animal dissection, surface observation, and received
wisdom. The animal dissections were of two basic types: those that were
straightforward investigations of individual species, and those conducted to
shed light on human anatomy.

Of the latter type, Leonardo's favored subjects seem to have been
the pig (a common choice for anatomists, see cat. 8b) and the monkey. He
never abandoned the standard view that "all terrestrial animals resemble
each other as to their limbs . . . and they do not vary except in length or in
thickness [i.e., in proportion]" (Paris Ms. G, f. 5v, c. 1510–11).[5] At this
early stage it is thus impossible to quantify the amount of human material at

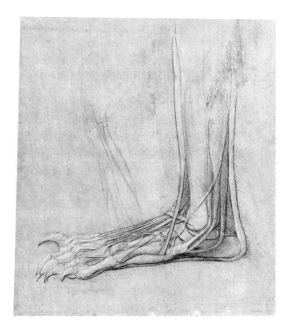 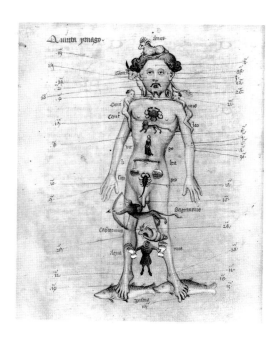

Leonardo's disposal (though it was undoubtedly small), for it is difficult to discern in each case whether he is presenting a poorly understood human dissection, or an animal dissection adjusted to fit a human form.

More rewarding than his applications of animal anatomy to the human form were his investigations of animals in their own right. Almost entirely lost are the fruits of an extensive study of the horse's anatomy (see cat. 3b), but a series of the dissected paws of bears includes some of Leonardo's finest early anatomical drawings (fig. 6). It is clear that from the start, his interests went far beyond what was immediately of use to the artist, and the reasons behind this depth of enquiry must be elucidated to understand the context of his first period of anatomical work.

Leonardo believed deeply in the scientific nature of painting. His insistence on the ultimate and absolute veracity of every element had its source in the tradition of Florentine objectivity as typified by Alberti; but Leonardo wished to go way beyond the limits of material analysis, to an integrated understanding of every facet of the universe. The particle physicists and cosmologists of the late twentieth century are still striving to uncover the Grand Unified Theory, the "theory of everything," and that is, in essence, the goal Leonardo set himself five hundred years ago.

Despite his insistence on the supremacy of experience in this quest, repeated throughout his life, Leonardo needed a theoretical framework within which to evaluate his observations. Unavoidably, he sought this in the writings of his predecessors. Painfully aware of his lack of book-learning—Leonardo had little knowledge of Latin, the language of most of the standard texts—and with a somewhat ingenuous attitude towards authority, he struggled to assimilate the principles of natural philosophy as formulated in antiquity and echoed down through medieval corruptions and classical revivals to his own day.

For the anatomist, primary among these constructs was the microcosm/macrocosm analogy, which paralleled in various ways the structure of man with the structure of the universe. This was not merely a poetic image: the Zodiac Man, a common feature of medieval cosmographiae (fig. 7), rendered this analogy in concrete form. The zodiac, the outermost sphere of the universe, governed the external anatomy of man;

15

the planets held influence over the viscera; and the moon, innermost of the "planets," controlled the movements of the terrestrial fluids (the tides) and the bodily fluids (the "humors"—black bile, yellow bile, phlegm, and blood —so accounting for the menstrual cycle). About 1490 Leonardo wrote of the material aspect of the analogy:

> Man has been called by the ancients a lesser world, and indeed the name is well applied; because, as man is composed of earth, water, air, and fire [the four "elements" of the ancients], this body of the earth is similar. Whereas man has bones within himself, the supports and framework of the flesh, the world has rocks, the supports of the earth; if man has within himself the lake of blood, wherein the lungs expand and contract in breathing, the body of earth has its ocean, which also expands and con-tracts every six hours with the breathing of the world; as from the said lake of blood arise the veins, which spread their branches through the human body, likewise the ocean fills the body of the earth with an infinite number of veins of water. (Paris Ms. A, f. 55v)

Elsewhere, Leonardo even tried to relate the period of the tides to the period of human breathing, using a scaling factor. His intractable difficulties with the mathematics involved do not diminish the sincerity of the attempt.

This analogizing mode of thought was hugely attractive to Leo-nardo, pervading all his writings, and was responsible both for some of his most brilliant successes and for some of his more stubborn failures. One observation sparked a second, analogous insight, which itself led to another observation, and so on, *ad infinitum*. Leonardo could never reach the boundaries of a field of interest: there was always more to be known about a subject, and thus this staggeringly productive man never finalized, to our knowledge, any of the treatises he set out to write.

A second aspect of traditional thought that Leonardo seized upon about 1490 was a concern with proportion. Like the macrocosm/microcosm analogy, a belief in the existence of fixed ratios within and between the parts of the universe originated in a conviction of the order and harmony of the physical world. Proportion, being susceptible to analysis and manipula-tion, received much attention from the Renaissance art theorists—the search for a canon of ideal beauty was obviously no abstract exercise. But beyond a conventional study of the external proportions of the human body, which can be seen in several sheets at Windsor, Leonardo also investigated internal form in proportional terms, part of a wider neurological study (cats. 1a–2b) that constituted one of the few focuses of his haphazard early work.

In theory, at least, this was important to the artist: "The good painter has two things to paint, that is, man and the intention of his mind."[6] But understandably at a loss to find any scientific (rather than intuitive) way of correlating the body's attitudes with the mental state, Leonardo's initial efforts went no further than speculations on the sites of the mental faculties (cat. 1a; but see also cat. 11), reworkings of medi-eval theory that may convey aspects of his personal philosophy, but that are in themselves anatomically insignificant. However, a by-product of this endeavor was a series of drawings of the skull (including cats. 2a–b), magnificent studies of morphology that unintentionally overshadow the purpose of the diagrams.

Though the evidence available today suggests that Leonardo's first wave of anatomical work subsided after 1492, his two major projects of the

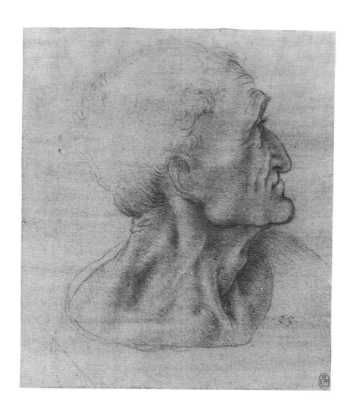

Fig. 8
Leonardo da Vinci, *Head of Judas*. Red
chalk on pink prepared paper. Windsor
Castle, Royal Library (RL 12547).

1490s were intimately connected with these early themes. The huge equestrian monument to Francesco Sforza, which was never cast, provoked many studies of the horse's proportion, as well as the lost anatomical studies. And the "intention of the mind" is the dominant theme of the *Last Supper* mural; in the red-on-red study for the head of Judas (c. 1497, fig. 8), the tensed muscles of the neck and jaw are the principal vehicles of expression.

The end of the century saw the fall of Milan to French forces. Deprived of the patronage and protection of the Sforza court, Leonardo moved, via Venice, back to Florence in 1500, to begin the most productive decade of his career.

SYNTHESIS
c. 1504–1509
The revival of Leonardo's anatomical studies in the years after 1504 was precipitated by one of his most prestigious commissions. Italy was in more than its usual turmoil, and the embattled Florentine Republic planned to glorify its past achievements, thus asserting its present status, in a decorative program of unparalleled grandeur for the Council Chamber of the Palazzo Vecchio. The whole scheme was begun by the architect Antonio da Sangallo in the mid 1490s, and sometime in 1503 Leonardo received the contract for a huge mural of the *Battle of Anghiari*, a celebrated victory of 1440 over the Milanese forces.

The commission pitted Leonardo, then past his fiftieth year, against the most brilliant of a younger generation of Florentine artists. Michelangelo, fresh from his triumph with the marble *David*, was assigned the contract for the *Battle of Cascina* in 1504, planned as a direct counterpart to Leonardo's mural. Neither was completed; diplomatic expediency on the part of the Florentine Republic propelled Michelangelo to the Papal Court in 1505 and Leonardo back to Milan a year later. But while the projects were fresh, each artist took the opportunity to explore his own foibles on a monumental scale.

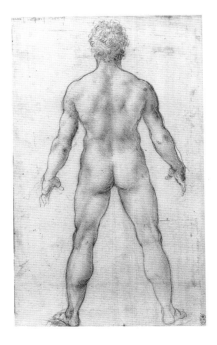

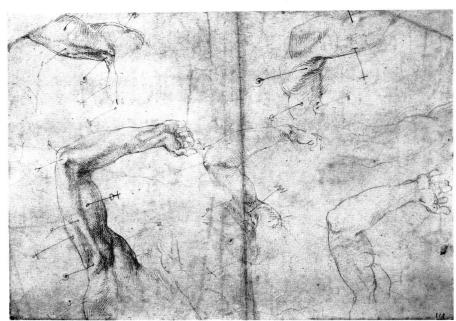

Fig. 9
Leonardo da Vinci, *Male nude*. Red
chalk. Windsor Castle, Royal Library
(RL 12596).

Fig. 10
Michelangelo, *Studies of the arm*.
Black chalk and pen and ink. Vienna,
Albertina (Sc.R.167).

The copies that have come down to us show that Michelangelo chose his episode to represent the nude in poses of extreme variety, while Leonardo concentrated on man and horse in violent action and reaction. Both concerns demanded an extensive knowledge of anatomy, and from about 1504, Leonardo surveyed the superficial aspects of man in a prolonged series of studies (fig. 9) which, in the Florentine tradition, presume a knowledge of flayed corpses.

Michelangelo, meanwhile, was already an anatomist of considerable sophistication. The paucity of surviving drawings from his earliest projects makes a precise assessment impossible, but both Ascanio Condivi (1553) and Vasari (1568), friends and biographers of the artist, claimed that he had performed dissections in the Ospedale di Santo Spirito, Florence, before 1494 (when only nineteen years old).[7] Certainly the body of Christ in the Rome *Pietà* of 1498–99 displays an understanding of structure that is inexplicable without a prolonged campaign of deep dissection of the human form.

Several studies for the *Battle of Cascina* (fig. 10) show that by 1504 Michelangelo had evolved a consistent vocabulary of symbols to identify individual muscles for which no precise terminology had existed. His concerns were only those of the artist; Michelangelo was quite uninterested in tradition and speculation. This freedom, which used to be claimed (erroneously) for Leonardo, was in fact one of Michelangelo's great advantages. The clear-sighted objectivity of the *Cascina* studies was not to be matched by the older artist until 1510.

Characteristically, Leonardo's renewed anatomical efforts soon became divorced from the practicalities of the *Anghiari* project. More experienced than before, and quite probably with easier access to human material, he turned his attention to independent studies of the deeper systems of the body, both towards the end of his Florentine sojourn and after his return to Milan in 1506. But it appears—and in making such statements one must be continually mindful of the huge losses that Leonardo's manuscripts have suffered—that a chance occurrence sparked five years of sustained investigation, during which were concentrated most of Leonardo's finest achievements.

Temporarily in Florence during the winter of 1507–8 in order to resolve problems arising from an uncle's will, Leonardo was present at the peaceful demise of an elderly man in the hospital of the monastery of Santa Maria Nuova, an institution used by Leonardo and others as a bank and a repository of books and drawings. His ongoing interest in the organic nature of man prompted him to perform a dissection, "to see the cause of so sweet a death" (see cat. 5a). The resulting series of drawings is the most complete record we have of a single dissection, but we must beware of reading the drawings as objective accounts of what Leonardo actually saw.

It seems that the extant drawings were actually executed later in 1508, after Leonardo had returned once more to Milan—certainly they are not the notes made in the course of a messy dissection. Leonardo resumed compilation of the notebook begun in 1489 with the skull studies such as cats. 2a–b; several of the pages are headed *del vecchio*, "of the old man," and Leonardo clearly conceived those drawings as specific depictions of the "centenarian's" dissection. But the organs and vessels are spaced out, regularized, and synthetically presented in a way that has little to do with the compactness evident on opening the human abdomen (see especially cats. 6a–8a and 12a).

The leanness of the old man allowed Leonardo to make his most extensive investigation of the viscera of a human. His goal was to determine the systems responsible for bodily functions, but he was virtually indifferent to biochemistry; beyond rudimentary statements concerning the humors, his considerations were primarily in terms of fluid mechanics, Leonardo's other main interest about 1508.

Misunderstood physiology thus often led to inaccurate anatomy, for the drawings were the result of a complex interplay of perceived function and observed form. Cat. 12a, probably executed in 1509, represents the culmination of this approach, for shortly afterwards Leonardo's methodology was to change fundamentally.

ANALYSIS
1510–1513
A dazzling series of sheets that forms the so-called Anatomical Manuscript A (including cats. 13a–16b and 18a–21), datable to the winter of 1510–11 (see cat. 21), concentrates on the osteological and myological systems in a thoroughly objective manner. Previously, Leonardo's method had been to interpret what he saw in the light of what he knew, recording this interpretation. In the sheets of Anatomical Ms. A, Leonardo first recorded what he saw, then investigated the mechanical functions of the observed form: analysis replaced synthesis. The accuracy of his drawing was no longer compromised by the limits of his understanding.

What precipitated this break with the past? Leonardo's notes, usually impersonal and sometimes even misanthropic, are silent on the matter. But Vasari, who saw the drawings at the villa of Francesco Melzi, Leonardo's pupil and heir, wrote that "Leonardo applied himself . . . to the study of human anatomy, in which he collaborated with that excellent philosopher, Marcantonio della Torre,"[8] and there is substantial circumstantial evidence to support this assertion.

Marcantonio was the young professor of anatomy at the University of Pavia, twenty miles south of Milan. Before he died of the plague in 1511 at about age thirty, he was, as Vasari went on to note, "one of the first to illustrate the problems of medicine by the teachings of Galen,"[9] a revival

that culminated in Vesalius's ground-breaking work thirty years later. His friendship with Leonardo from 1509 or early 1510 is the only plausible explanation for the sudden shift towards Galenism in the artist's subsequent investigations.

Rather than any points of detail which he gleaned—though these are numerous—it was Galen's teleology that most profoundly influenced Leonardo. This doctrine holds that every part has a function, that nothing is superfluous, in a body perfectly made by the Creator. Reflections of the belief are replete throughout Leonardo's notes of 1510–13, but its effect was much more than purely philosophical.

The new teleology enabled Leonardo, for the first time in his anatomical career, to make full use of his greatest gifts, as an observer and a recorder. In Anatomical Ms. A, attempts to understand physiology came only after Leonardo had rendered physical reality as accurately as he could. The resulting sheets thus contain some of the finest anatomical drawings ever created.

The excitement behind these studies is palpable. On a sheet concerning the bones of the arm (RL 19004v) there is the note, "see what the gibbosity of the arm at f [deltoid tubercle] serves," followed by, "I have looked, and find that the gibbosity f serves to attach the [deltoid] muscle which raises the major bone of the arm." There is no guessing: everything is based on material investigation.

The above passage implies a ready availability of human material at this time, and indeed the number of human dissections claimed by Leonardo grows from "more than ten," about 1509, to "more than thirty" towards the end of his life. Paolo Giovio, a friend both of Leonardo and of Marcantonio (and, later, of Vasari), recorded in his highly accurate but frustratingly brief biography of the artist, written in 1527, that "in order that he might be able to paint the various joints and muscles as they bend and stretch according to the laws of nature, he dissected in medical schools the corpses of criminals, indifferent to this inhuman and nauseating work,"[10] and a note on Paris Ms. G, f. 1v, dated January 5, 1511, implies recent contact with a Pavian sculptor, "Master Benedetto" (probably identifiable as Benedetto Briosco). Though mere hypothesis, it is quite possible that Leonardo was working in the medical school of the University of Pavia, with Marcantonio, when he compiled Anatomical Ms. A in the winter of 1510–11.

Any collaboration between the two was cut short by Marcantonio's death the following year. With the exception of a handful of studies of embryology (e.g., cats. 22a–b), a topic of enduring fascination to Leonardo and somewhat outside the mainstream of his activity in these years, the next and last campaign of which we have evidence was a prolonged study of the heart dating to approximately 1511–13 (e.g., cats. 23a–b).

As a unit, the heart enabled Leonardo to integrate his observational skills, his understanding of mechanics, and his intuitive grasp of fluid dynamics. In a brilliant investigation of the function of the valves, he constructed a glass model of the aortic valve and sinuses of Valsalva by taking a cast from an ox's heart (fig. 11). Observing the vortices in the sinuses, he correctly deduced the mechanism of closure of the valves, reaching conclusions that are still being verified in the light of modern research.

Leonardo identified the auricles, described the movements of diastole and systole, and understood perfectly the functioning of the valves. Had he followed his mechanistic instincts, it is hard to see how the discovery of the circulation could have eluded him. But Leonardo was dogged by pre-

Fig. 11
Leonardo da Vinci, *The valves and sinuses of the heart*. Pen and ink on blue paper.
Windsor Castle, Royal Library
(RL 19082).

conceptions derived from written authority, and he never discarded the ancient views that the arteries conveyed "vital spirit," that the veins nourished, and that the two systems were independent. He altered his description of the closure of the valves to allow for flux and reflux of the same blood in and out of the ventricles (the turbulence in the sinuses being the source of the body's innate heat). The pulmonary system existed simply to refresh the blood and to prevent the heart from overheating; he even accepted the doctrine of a perforated intraventricular septum, despite not being able to see any pores, finally deciding they were too small to be visible.

This collapse of empiricism is the most disappointing aspect of Leonardo's late work. As it stands, the uneasy combination in the heart studies of remarkable insight and stifling tradition may be seen as representative of the whole of the artist's anatomical career.

In late 1513, Leonardo moved, with his pupils, to Rome. We know he conducted anatomical investigations in the Ospedale di Santo Spirito, but we have little record of the extent of his researches there, and few resulting drawings can be firmly identified. In 1515 Leonardo was slandered before Pope Leo X by an unsavory acquaintance, a German mirror maker known as Giovanni degli Specchi, who accused him of unspecified sacrilegious practices. As a result, Leonardo found himself in papal disfavor and barred from Santo Spirito, and his anatomical career came to an undignified end.

IL LIBRO DELL'ANATOMIA

It was always Leonardo's intention ultimately to publish a treatise on anatomy. Several outlines for the book and its parts survive, and as if his own testimony on cat. 13a were not sufficient, we have Paolo Giovio's explicit

statement of 1527: "He then tabulated with extreme accuracy all the different parts, down to the smallest veins and the composition of the bones, in order that this work on which he had spent so many years should be published from copper engravings [*typis aeneis*] for the benefit of art."[11]

The huge losses of his anatomical work make it impossible to assess how complete was his coverage of the human body—as early as c. 1509 he referred to "the one hundred and twenty books [i.e., chapters] which I have composed" (RL 19070v), nearly all of which must have vanished; but the obsessive detail of the latest studies suggests he was as far away from completing his work then as he was in 1489. Vasari's typically astute assessment of his character was that "Leonardo's profound and discerning mind was so ambitious that this was itself an impediment; and the reason he failed was that he endeavored to add excellence to excellence and perfection to perfection."[12] Leonardo only achieved a working compromise between coverage and detail in Anatomical Ms. A, when the influence of a professional anatomist, Marcantonio della Torre, might have prevented him from becoming bogged down in minutiae. After Marcantonio's death in 1511, the studies reverted to an arbitrary range of interests, from the valves of the heart to the viscera of the embryo.

Had the material ever reached a stage of completion suitable for publication, a more practical problem would have faced Leonardo: the method of reproduction of the drawings. The woodcut, which was the standard technique for book illustration, could not possibly have coped with the refinement and tonal subtleties of Anatomical Ms. A, as Leonardo implied in the plea to his successors on cat. 13a.

The only reproductive medium that could have done justice was copper engraving, the method mentioned in the passage by Giovio, quoted above. However, this was prohibitively time-consuming, and therefore expensive. There is much evidence that Leonardo experimented with a novel process of relief etching from an early stage. The technique, described in Madrid Codex II, f. 119r, allows the artist to scratch, freehand, through the surface of a coated plate, before producing a "negative" of the coating, and then biting the plate. The drawn lines are left in relief, and a print is taken as for a woodcut, but the process is more flexible and the resulting reproduction is of a higher standard: two fragments of a print of horses' heads at Windsor, apparently made using this method, were long thought to be drawings (RL 12287–88).

Leonardo also seems to have made prints, presumably about 1490, after some of his earliest anatomical drawings. Several pages of Albrecht Dürer's *Dresden Sketchbook* of 1517 must be copies after such prints (e.g., fig. 12; cf. RL 12613v, fig. 5), the few impressions of which have all been lost; the later, anatomically more significant, drawings apparently went unreproduced (but see cat. 21). Any propagation of their content after Leonardo's death was solely through visits by interested parties to Melzi's villa, and though it may be possible to detect traces of their influence in such tracts as Johannes Dryander's *Anatomia* of 1537, they were effectively lost to the world.

In 1543, Andreas Vesalius published his *De humani corporis fabrica*, a long and detailed work based on both human dissection and an extensive but critical knowledge of Galen. It was illustrated with many fine woodcuts (fig. 13), probably by the Flemish artist Jan Stefan van Calcar, then working in Venice under Titian's influence. The symbiosis of Jan Stefan's clarity and Vesalius's observation and system made it the most important single work in the history of European anatomy.

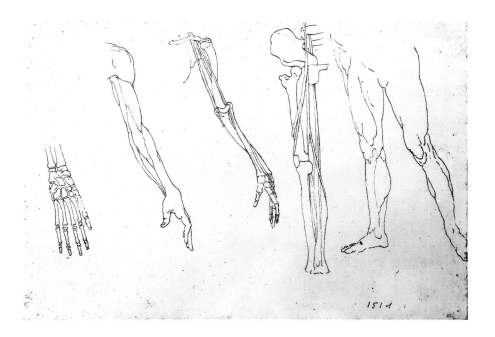

Fig. 12
Albrecht Dürer, *Studies of the leg and arm, after Leonardo*. Pen and ink. Dresden, Sächsische Landesbibliothek (*Dresden Sketchbook*, f. 130v).

Fig. 13
Jan Stefan van Calcar, *Fourth Muscle Plate*. Woodcut. From Andreas Vesalius, *De humani corporis fabrica* (Venice, 1543).

The *Fabrica* was everything that Leonardo's collaboration with Marcantonio could have been, had the plague not struck Pavia in 1511. Only since the turn of this century have Leonardo's anatomical drawings been widely accessible. We are the "successors" addressed by Leonardo on cat. 13a, and our privilege brings with it a measure of responsibility. The efforts of a century of scholars have unraveled the chronology of the drawings, and the balance sheet of accuracies and inaccuracies has been compiled. The way is now clear to put aside our twentieth-century prejudices and to see what we, in turn, can learn from the work of the greatest artist-anatomist ever to have lived.

NOTES
1. Leon Battista Alberti, *On Painting and On Sculpture*, ed. and trans. C. Grayson (London: Phaidon, 1972), 75.
2. ". . .scorticò molti huomini, per vedere la notomia lor sotto." See, e.g., Giorgio Vasari, *The Lives of the Artists*, trans. G. Bull (London: Penguin, 1987), 2:76 (where *scorticò* is incorrectly rendered as "dissected"), and many other editions.
3. See J. B. Schulz, *Art and Anatomy in Renaissance Italy* (Ann Arbor, Michigan: UMI, 1985), 36 ff.
4. See A. H. Mayor, *Artists and Anatomists* (New York: Artist's Limited Edition in association with the Metropolitan Museum of Art, 1984), ch. 1.
5. For this and all subsequent references to Leonardo's manuscripts, see the note at the beginning of the bibliography.
6. *Codex Urbinas*, f. 50 (this is a sixteenth-century transcribed compilation of Leonardo's writings, many of which are now lost, in the Vatican Library).
7. A. Condivi, *Vita di Michelagnolo Buonarroti*, 2nd ed. (Florence: G. Albizzini, 1746), 9; G. Vasari, *The Lives of the Artists*, trans. G. Bull (London: Penguin, 1965), 1:333.
8. Vasari, 1:264.
9. Vasari, 1:264.
10. J. P. Richter, *The Literary Works of Leonardo da Vinci*, 2nd ed. (London: Oxford University Press, 1939), 3.
11. Richter, 3.
12. Vasari, 1:264.

CATALOGUE OF THE EXHIBITION

PART ONE
c. 1487–c. 1495

ON THE ORDER OF THE BOOK
This work should begin with the conception of man and describe the form of the womb, and how the child lives in it, and to what stage it resides in it and in what way it is given life and food. Also its growth, and what interval there is between one degree of growth and another; and what it is that pushes it out of the body of the mother, and for what reason it sometimes comes out of the mother's belly before due time.

Then you will describe which parts grow more than others after the infant is born; and give the measurements of a child of one year.

Then describe the grown-up man and woman, and their measurements, and the nature of their constitution, color and physiognomy.

Then describe how they are composed of veins, nerves, muscles and bones. This you will do at the end of the book.

Then in four drawings represent four universal conditions of man, that is joy with different ways of laughing, and draw the causes of the laughter; weeping in different ways, with their cause; fighting, with the different movements of killing; flight, fear, ferocity, boldness, murder and everything belonging to such events.

Then draw labor, with pulling, pushing, carrying, stopping, supporting and similar things.

ATTITUDES
Then describe attitudes and movement.

EFFECTS
Then perspective through the function of the eye; on hearing, I shall speak of music; and describe the other senses.

SENSES
Then describe the nature of the five senses.

RL 19037v, c. 1489

1A.

THE CEREBRAL VENTRICLES, AND THE LAYERS
OF THE SCALP

c. 1489–90
Pen and ink with red chalk, 8 × 6 inches
(20.3 × 15.2 cm.)
RL 12603r
K & P 32r; O'M & S 142; Philo et al.
19–22; Woodburne 208–13, 273–78

LEONARDO CONSIDERED "simple and plain experience" to be "the true mistress," but this drawing is a curious hybrid of acute observation, vivid analogy, and unquestioning acceptance of authority.

The comparison of the layers of the head to an onion, a typical, but nonetheless striking Leonardesque analogy, is explained in the note at the left:

> If you cut an onion through the middle, you will be able to see and enumerate all the coats or rinds which circularly clothe the center of this onion. Similarly, if you cut through the middle of the head of a man, you will cut first the hairs, then the scalp, then the muscular flesh [galea aponeurotica] and pericranium, then the cranium, and inside the dura mater, the pia mater, and the brain; then again the pia mater and dura mater and the rete mirabile and then the bone, the foundation.

The flesh-and-blood nature of the notes and the realism of the drawings can be misleading. Leonardo presented the diagrams above and below as what would be seen if the head were sawn through, sagittally and at eye level respectively. But the structure of the brain shown is entirely fanciful, a visual summary of tradition.

Corruptions and modifications of ancient theories, from Aristotle, through Galen, Arab translators and commentators, and European philosophers and anatomists, had led to a belief in the late fifteenth century that the brain contained three bulbous ventricles, leading back in a line. The mental faculties were believed to be distributed among these three parts.

The first ventricle contained the *sensus comunis*, on which all the sensory nerves converged, along with the imaginative faculties, *fantasia* and *imaginatio*. From there, impulses were passed for processing to the middle ventricle, site of the intellectual faculties *cogitatio*, *estimatio*, and so on. The posterior ventricle held the results in *memoria*.

Just this arrangement is shown in a woodcut from a German philosophical compendium of 1503 (fig. 14), and it is clear that Leonardo subscribed to this tradition. His placing of the anterior ventricle directly below the bregma defines it as the site of the *sensus comunis*, as detailed on cat. 2b. Oddly, he did not actually identify the ventricles on this sheet, and indeed the arrangement implied in this drawing is not described by Leonardo on any surviving sheet.

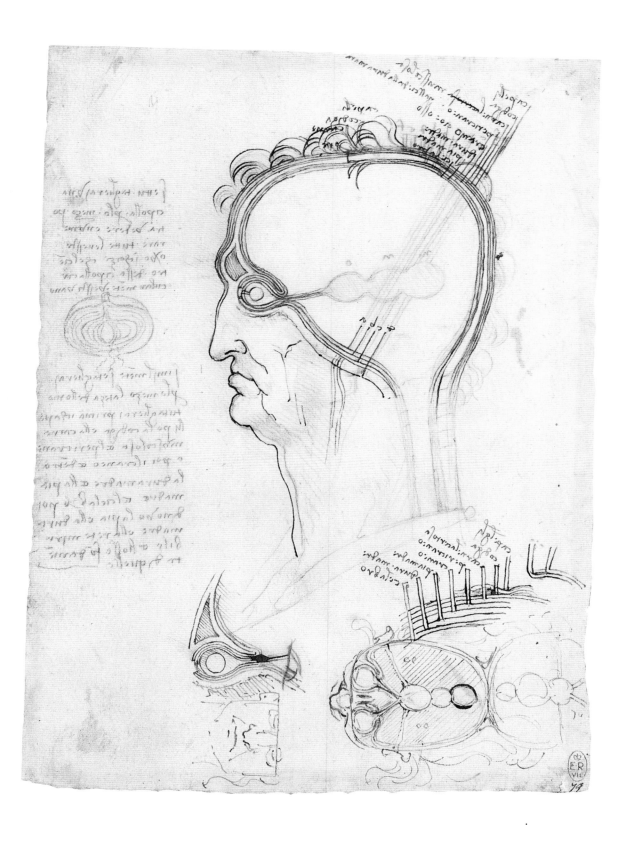

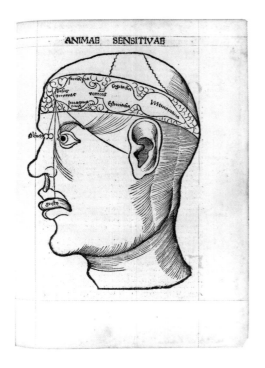

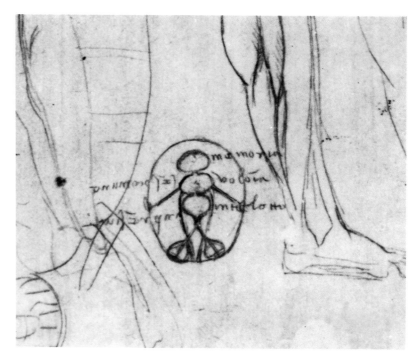

A little later, on RL 12626, he radically altered the arrangement (fig. 15). There, only the optic nerves lead to the first ventricle, which he identified as the site of the intellect and the *imprensiva*. This faculty, a concept apparently invented by Leonardo, received impressions (here perceived only in visual terms) and passed them to the *sensus comunis* in the middle ventricle. All the other sensory nerves led directly to the middle ventricle, site also of *volontà*, the origin of voluntary action. *Memoria* remained in the third ventricle.

Shortly afterwards, Leonardo was to abandon the primacy of vision in the ventricular arrangement:

> The *senso comune* is that which judges of things offered to it by the other senses . . . [it] is placed in the center of the head between *imprensiva* and *memoria*. Surrounding things transmit their images to the senses, and the senses transfer them to the *imprensiva*. *Imprensiva* sends them to the *senso comune*, and by it they are stamped upon the memory and are there more or less retained, depending upon the importance or potency of the given thing. (C.A. f. 90r-b, c. 1490–92)

When Leonardo returned to the problem in about 1508, this simple arrangement was revived and applied to a layout of the ventricles as derived experimentally (see cat. 11).
—M.C.

NUMEROUS FLAWS EXIST in this view of layers of the scalp, the meningeal coverings of the brain and orbit, and the ventricular system of the brain. The drawing does contain an early, possibly the first, depiction of the frontal sinus above the orbit. The layers of the scalp, the skull, and the brain are essentially correct, and still relevant to today's students. The membrane that is now known as pia mater is intimately attached to the

brain and not visible to the naked eye; therefore, when Leonardo lists the layers encountered from the outside in, he likely implies the arachnoid mater rather than the pia mater. Leonardo was unaware of the diverse layers comprising just the scalp. He accurately described the dura mater as covering the optic nerve, but placed the lens at the center of the globe of the eye rather than at its front. The innovative concepts illustrated at the bottom of the sheet are references to the level of the transverse section through the orbit (a diagram still used today) and a flip-top view of the inside of the skull, with the top half upside down on the right and still hinged to the bottom half.

—R.P.

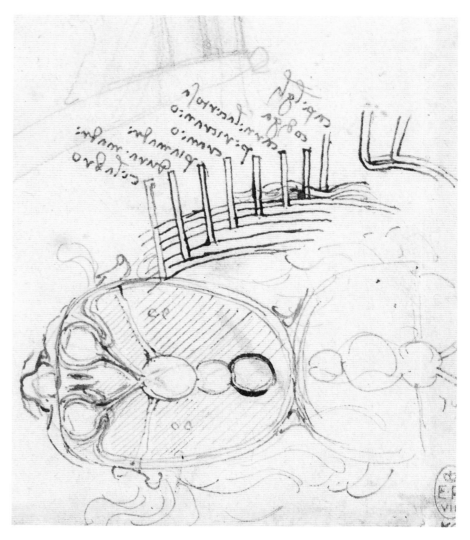

The layers of the scalp and the hinged skull: detail of cat. 1a.

THE CEREBRAL VENTRICLES, AND OTHER STUDIES

c. 1489–90
Pen and ink, oxidized white, and faded
metalpoint, 6 × 8 inches (15.2 ×
20.3 cm.)
RL 12603v
K & P 32v; O'M & S 143; Snell and
Wyman 388–89

THE ORDER IN WHICH the sketches on this sheet were added may be reconstructed with some confidence. An earlier profile and other scribbles drawn in ink by a pupil of Leonardo were obliterated with lead white, the oxidation of which has rather confused the clarity of the sheet. Two further profiles drawn in metalpoint on the unprepared surface are now only visible in ultraviolet light. Leonardo then turned the sheet on its side and drew the frontal view of a transparent head at center right, with the optic nerves receding to the three ventricles. On the other half of the sheet, he drew a comparative view of a complete head, with the same outlines and central vertical line clearly visible (Leonardo's left-handedness led him habitually to compile his sheets from right to left).

The technique of parallel projection, the construction of one view of an object from another (frequently at right angles to each other) by a sequence of parallel lines drawn from salient points, was appropriated by artists from architectural practice during the late fifteenth century in Italy, and developed by theoreticians such as Piero della Francesca and Leonardo. Later, Albrecht Dürer was to use the procedure extensively in his treatise on geometry of 1525 and *Four Books on Human Proportion* (*Vier Bücher von Menschlicher Proportion*) of 1528 (fig. 16). Below the earlier transparency, Leonardo illustrated the procedure explicitly; the rather naive and aimless

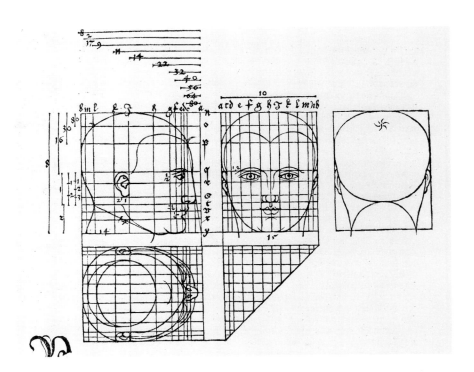

Fig. 16
Albrecht Dürer, *The proportions of the head*. Woodcut. From *Vier Bücher von Menschlicher Proportion* (Nuremberg, 1528).

diagram suggests he had only recently become acquainted with its application to the human figure.

Finally, two further frontal views explore the method of transparency more fully. The spatial ambiguity of the drawings evidently discouraged Leonardo from developing this presentation of the vessels of the head. —M.C.

LITTLE ANATOMICAL KNOWLEDGE is advanced by these perspective studies of the head. The drawings grouped on the right are phantom-style projections of deeper structures as if viewed through a transparent surface. The trained eye may discern the path of the common, external, and internal carotid arteries, as well as the eyes and optic nerve on the top right. This sketch bears an uncanny resemblance to a modern AP carotid arteriogram. The concept of parallel projection or "transformation," still of practical use today, allows a section or surface of the body to be reproduced if two mutually perpendicular surfaces are known. Therefore, one should be able to draw a cross section if a frontal and side view are known. Today, in diagnostic imaging, the reverse logic is used: the imaged sections from a magnetic resonance imager (MRI) are calibrated and the computer can reassemble a view of the surface, or of any section, at an angle to the original sections. —R.P.

2A.

THE SKULL SECTIONED

1489
Pen and ink over traces of black chalk,
7¹/₂ × 5³/₈ inches (19.0 × 13.7 cm.)
RL 19058v
K & P 42v; O'M & S 3; Woodburne
262–73

INEVITABLY, WHAT ONE first appreciates in this sheet is the breathtaking virtuosity of the draftsmanship. Following the usual fifteenth-century practice, Leonardo would have first learned to draw using metalpoint — a stylus of silver, copper, lead, or an alloy — on prepared ground. This technique produces a fine, regular line which is unaffected by the pressure and speed of the stylus. A surface must, therefore, be built up slowly as a veil of lines, a procedure which is capable of great sensitivity, as shown by some of Leonardo's metalpoint studies of horses from about 1490.

This rigorous training in metalpoint enabled him to use pen and ink in a comparable manner here. His modeling of the bone with parallel lines attains a hardness of structure that has origins in both Florentine formal veracity and Flemish surface naturalism — an aspect of Leonardo's art which is being revealed by the exemplary restoration of his *Last Supper* mural. He has subtly manipulated the play of light to register nuances of the bone structure that an artist uninterested in anatomy would neglect: it must not be forgotten that the primary function of the drawing is scientific.

The text shows a concern with proportionality and the mental faculties typical of Leonardo's researches about 1490:

> The cavity of the eye socket, and the cavity in the bone that supports the cheek, and that of the nose and mouth, are of equal depth and terminate in a perpendicular line below the *senso comune*. And each of these cavities is as deep as the third part of a man's face, that is from the chin to the hair.

The sheet is one of a series of homogeneous skull studies from Anatomical Manuscript B, one of which (RL 19059v) is inscribed "On the 2nd day of April 1489," making it Leonardo's earliest dated anatomical drawing. This note probably records the commencement of the notebook, the majority of which was not to be compiled until c. 1506–9 (see cats. 5a–10). — M.C.

ONE CAN SAY LITTLE more to praise this drawing, accurate for use to this day, than have previous commentators. At once it is beautiful, it is unprecedented in the history of anatomical illustration, and it heralds the precision that would later be required in anatomy and medicine. Aside from these comments, one can note above the left-hand column of notes a schematic drawing of the four types of teeth. Here Leonardo has set straight an old argument, possibly begun by Aristotle, that asserted women have fewer teeth than men. Even though Leonardo may have quoted Galen through Avicenna on this matter, he obviously explored the problem and stated what

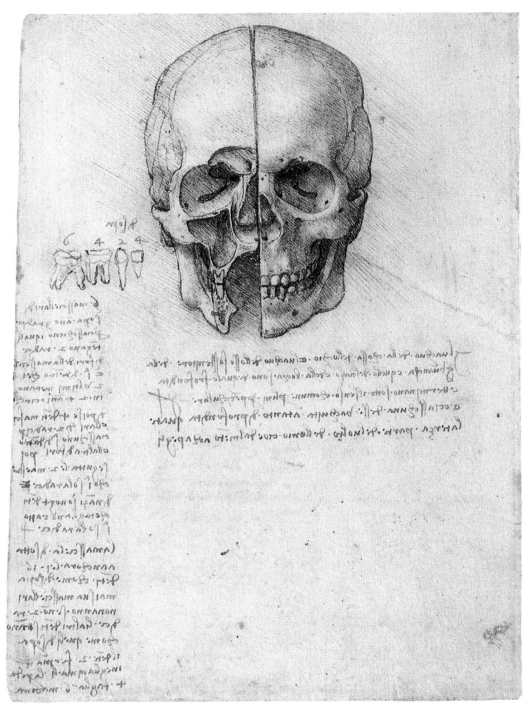

2A.

he observed. Though the schematic depictions of the teeth bear inaccuracies in their roots, the dental formula of 4:2:4:6 may easily be read, from right to left. This indicates four incisors, two canines, four premolars, and six molars—assuming eruption of the third set of molars or "wisdom teeth"—for each complete upper and lower jaw, thereby totaling thirty-two. Today, one would describe the dental formula as 2:1:2:3 for each half jaw, from midline to side, since it is a mirror image both left and right and upper and lower.

The technique of showing one half of the skull cut away to reveal structures at a different depth is still used today. In this case, a frontal section of the skull has been removed on the left side. Today's medical educators and imaging radiologists cannot help but note the prescient relevance of the sectional view to modern anatomical education. Beyond any doubt, Leonardo has shown the nasolacrimal duct proceeding from the medial aspect of the inferior orbit to the area of the anterior inferior nasal cavity known as the inferior meatus; the proximity of the roots of the maxillary teeth to the maxillary sinus is easily seen. So too is the communication of the mental foramen—a hole in the lower jawbone—with the mandibular canal indicated at the level of the frontal section.　—R.P.

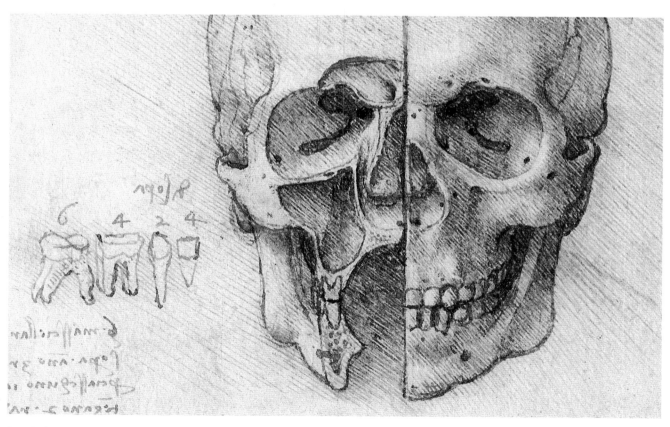

Detail of cat. 2a.

35

2B.

THE SKULL: INTERIOR VIEW

1489

Pen and ink over slight traces of black chalk, with scratching-out, 7¹/₂ × 5³/₈ inches (19.0 × 13.7 cm.)

RL 19058r

K & P 42r; O'M & S 6; Philo et al. 23, 26; Woodburne 262–73

AGAIN LEONARDO CHOSE the most appropriate section and viewpoint to demonstrate the location of the *sensus comunis*, in the anterior ventricle (see cat. 1a), at the geometric center of the head:

> The confluence of all the senses has below it in a perpendicular line the uvula, where one tastes food, at a distance of two fingers, and it is directly above the windpipe of the lung and above the orifice of the heart by a space of one foot. And it has the junction of the bones of the head half a head above it, and in front of it in a horizontal line is the lacrimator of the eye at one-third of a head. And behind it is the nape of the neck at two-thirds of a head; and at the sides are the two temporal pulses at equal distance and height.

But what appears to be a straightforward drawing of a sectioned skull is in fact a carefully contrived image. The near edge of the horizontal section is confused, with heavy working and scratching-out disguising a shift in viewing angle between the parts of the diagram. The floor of the cranial cavity is seen from a steeper angle than the bones of the face. Comparison with an actual similarly sectioned skull shows that this aspect is an impossibility. —M.C.

THE STRUCTURES SHOWN in this cutaway view outweigh the philosophical discussion on the confluence of the senses contained within the notes. The work again is unparalleled in its accuracy and concept. Here is the first accurate depiction of the meningeal arteries and their origination; Leonardo possibly depicted and mentioned an anastomosis or connection between intracranial and extracranial circulation at the orbit. The anterior, middle, and posterior cranial fossae are easily seen as the floor of the cranium stair-steps down from front to back. Roots of the great cranial nerves can be seen converging upon the intersection of the axes Leonardo has drawn. One must remember Leonardo's work predated the cell theory, the elaboration of circulation, the discovery of Galvanic responses, and electrophysiology. However inaccurate his study of function or physiology, his depiction of structure or morphology is essentially correct. One can only wonder how many dissections are represented here, the length of time that was required, and the conditions that must have been endured to depict accurately what we see here. —R.P.

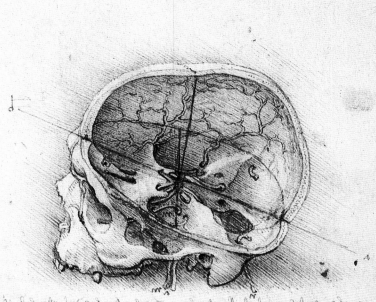

3A.

COITION OF A HEMISECTED MAN AND WOMAN

c. 1492–93
Pen and ink, 10¹/₂ × 8 inches (26.7 ×
20.4 cm.)
RL 19097v
K & P 35r; O'M & S 204; Philo et al.
244, 246, 249, 258

THIS SHEET IS AN EXTREME EXAMPLE of Leonardo's early tendency to create fictitious forms to fulfill speculative functions. The main drawing is a visual compilation of traditional sources, betraying both Leonardo's eclecticism and his early respect for authority, with no more basis in dissection than the theories of any of his predecessors.

From a debased Galenic tradition came the idea that the semen, which passes (with the urine) through a lower channel in the penis, is produced in the testes. From Hippocrates, via Avicenna (who is cited in the text), came the idea that the "animal spirit" is infused from the spinal cord, and thus Leonardo introduces a channel passing from the lumbar regions through the upper part of the penis. A later experiment, piercing the spinal medulla of an eviscerated frog, described on RL 12613r, convinced Leonardo that the spinal cord was the seat of life—the only documented case of vivisection throughout his researches.

Also shown is a fudged connection between the uterus and spinal cord. This demonstrates that Leonardo adhered to the Aristotelian view that both parents contributed generative matter to the formation of the child, rather than a simple sowing of the male seed in the fertile ground of the female. A tube from the uterus to the breasts allowed the transfer of the menses retained on conception, for the formation of milk; and a channel from the testicles, "the source of ardor," leads straight to the heart, the seat of the emotions.

A further note claims that "by means of these figures the cause of many risks of ulcers and diseases will be demonstrated." This has been interpreted as a reference to the epidemic of syphilis which swept Italy in the mid 1490s. Stylistically, the present sheet can be dated no later than c. 1493, which, if the interpretation of the note is correct, would support the theory that the epidemic was introduced by the return of Columbus's expedition from the Americas in 1493, rather than by the French invasion of Naples in 1495. —M.C.

AN ENGRAVING OF THIS PLATE was made in the late eighteenth century by Bartolozzi for John Chamberlaine and prints were circulated; later a facsimile was included in a book of works by Leonardo. Thus this drawing, one of the most inaccurate anatomical works by Leonardo, was one of the earliest to be reproduced. Some of the accuracies and inaccuracies are so obvious that they require no comment. However, one should note that the correct curvature of the spine is shown here; the spine was usually depicted as straight. The depiction of the alimentary tract is rudimentary. Before he died, Leonardo's anatomical accuracy far surpassed this example. —R.P.

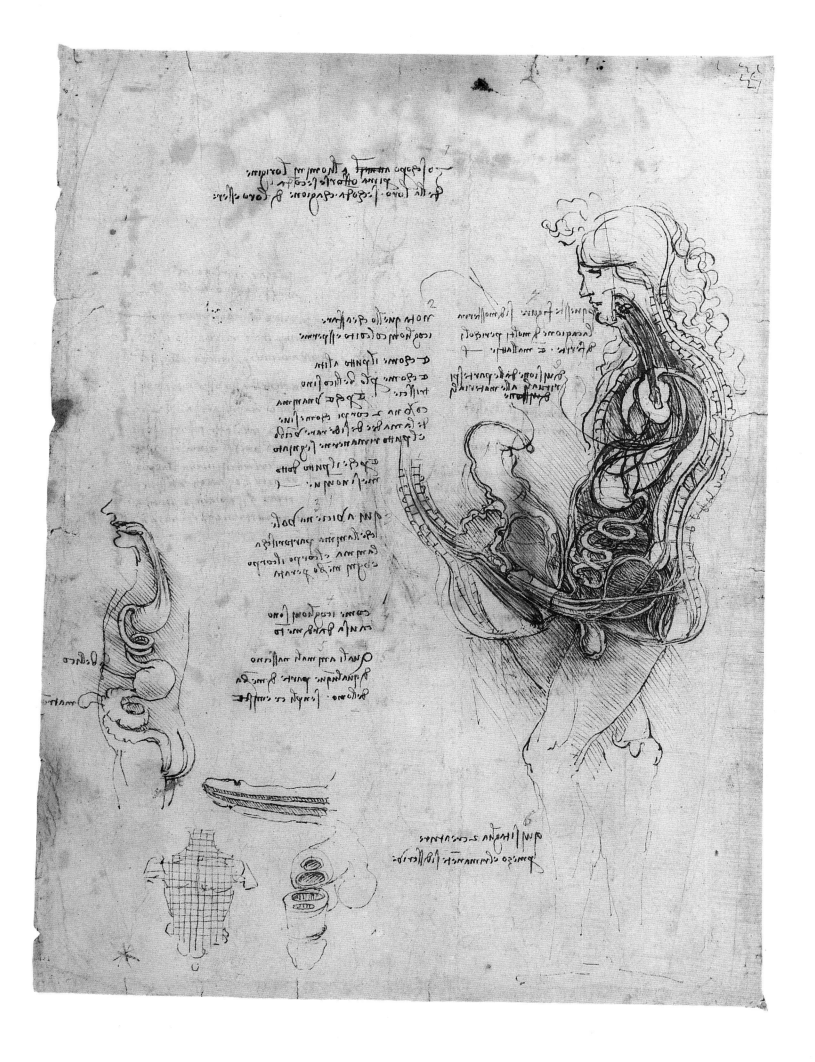

3B.

VISCERA OF A HORSE

c. 1492–93
Pen and ink, 10¹/₂ × 8 inches
(26.7 × 20.4 cm.)
RL 19097r
K & P 35v; O'M & S 117

LEONARDO'S WORK on the equestrian monument to Francesco Sforza in the early 1490s, and his interest in proportion at that time, led him to make many studies of the external measurements of horses. But this is one of the few surviving sheets to support Giorgio Vasari's assertion in 1568 that Leonardo composed a treatise on the anatomy of the horse during those years. The treatise was apparently lost when Leonardo left Milan in 1500, in the wake of the French invasion of the previous year. The huge clay model for the monument, used for target practice by French archers, met a similar fate.

The note at the lower left reads, "When you have finished building up the man, you will make the statue with all its external measurements." This has been interpreted as a reference either to the Sforza model or to a didactic sculpture for demonstrating human proportion. The latter interpretation is supported by a passage in Paris Ms. A, f. 1r (c. 1492): "Measurement and Division of the Statue: Divide the head into 12 degrees, and each degree divide into 12 points, and each point into 12 minutes, and the minutes into minims, and the minims into semi-minims." Many sheets from the period detail measurements of the human body, but there is no evidence that such a model was ever executed.

The slight sketch to the left—vertebrae joined to a testicle with a note "a cord arising from the spine which joins the vessel of the testicle"—is connected thematically with the drawing on the verso of the sheet. —M.C.

AS THE SUBJECT MATTER of this drawing is the horse, little new anatomy applicable to the human is displayed here. One possible exception is a description of the formation of the popliteal artery as a result of the passage of the femoral artery from the anterior thigh to a position posterior to the knee. —R.P.

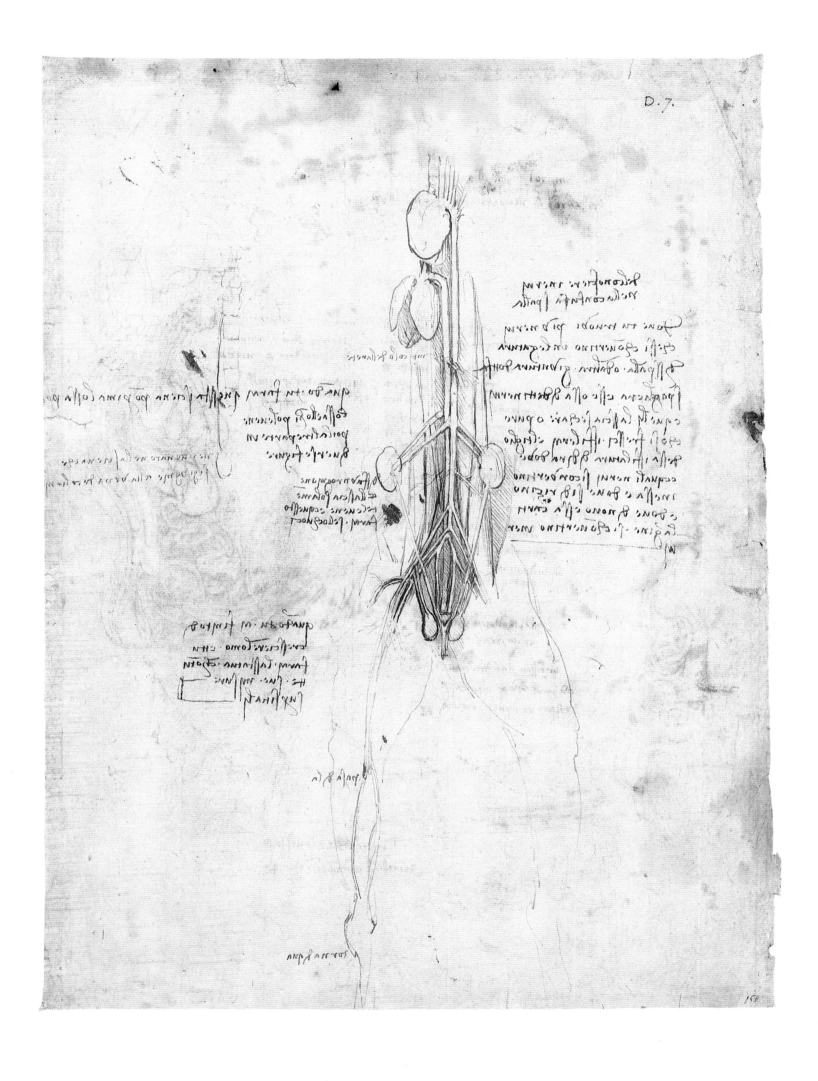

4.

"TREE OF THE VESSELS"

c. 1494–95
Pen and ink over black chalk, with
colored washes, 11 × 7 ¹³/₁₆ inches
(28.0 × 19.8 cm.)
RL 12597r
K & P 36r; O'M & S 116

THIS DRAWING IS A DIRECT descendant of the "bloodletting man," one of the standard medieval series of "situs figures"—five illustrations showing the systems of bones, muscles, vessels, viscera, and nerves schematically related to the outlines of the body (occasionally with an additional figure of the gravid female). Leonardo's immediate source was an illustration (fig. 17) from the 1494 Italian edition of Ketham's *Fasciculo de Medicina*, a compendium of medical tracts including Mondino's *Anathomia*. On grounds of style, the drawing cannot be substantially later than this publication date.

To the woodcut figure, Leonardo has added the courses of the vessels and an arrangement of the internal organs derived from animal dissections (cf. cat. 3b), Plato's *Timaeus*, and other traditional sources. (Coincidentally, the figure of Plato in Raphael's *School of Athens* fresco, generally accepted as a portrait of Leonardo, shows the aged artist/philosopher clutching a copy of the *Timaeus*.) The drawing is labeled (between the legs) "Tree of the Vessels" and (upper left) "Spiritual parts." The role of the vessels in carrying spirits was central to the physiology of Galen and his medieval followers. Here Leonardo has adopted the Galenic arrangement for the venous system, arising from the liver, to carry the "natural spirits" (that is, nourishment). The arterial system, originating

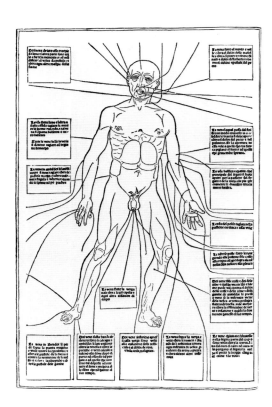

Fig. 17
Unidentified Venetian artist, *Bloodletting man*. Woodcut. From Johannes de Ketham, *Fasciculo de Medicina* (Venice, 1494).

42

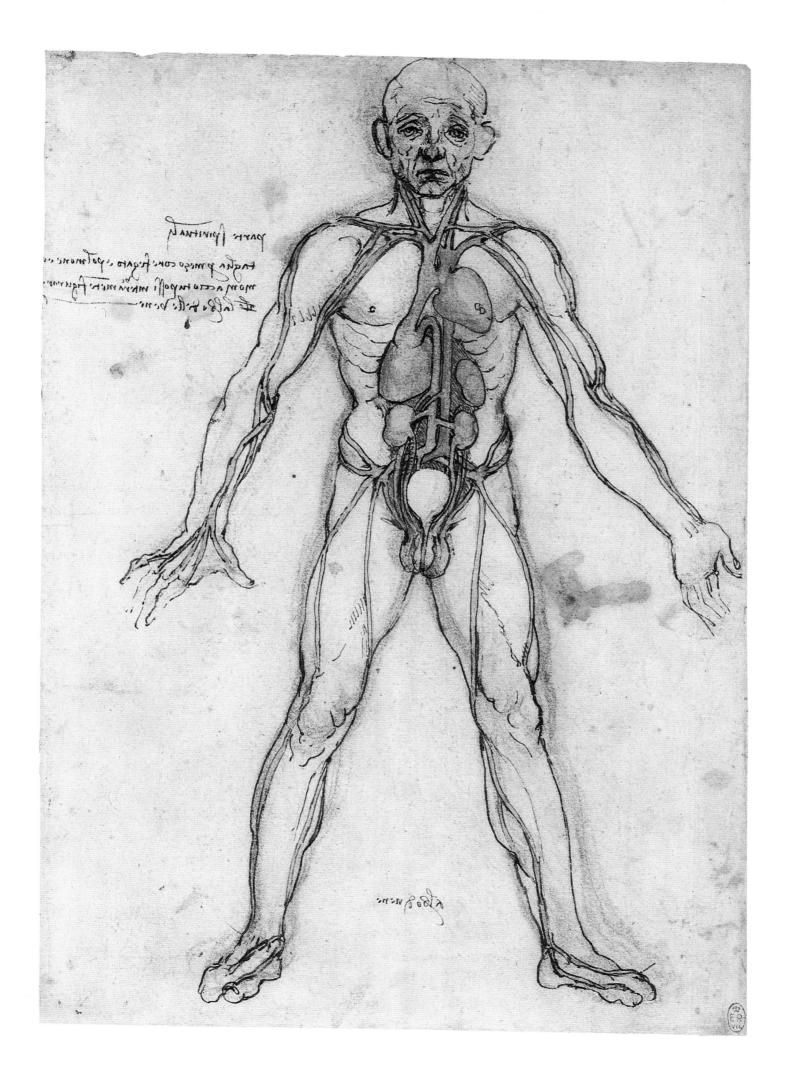

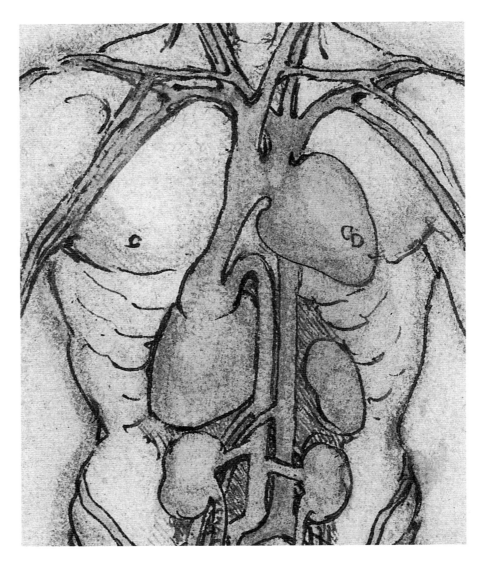

Detail of cat. 4.

in the left side of the heart, carried the "vital spirits." Leonardo was later to refute this arrangement, arguing in cat. 6a that the venous system also arose from the heart.

The method of displaying the systems of the situs figure within the outline of the whole body appealed strongly to Leonardo's holistic approach. He was repeatedly to insist upon the necessity of representing the outline even when considering the innermost parts (see the note on cat. 5b). He would not discard the method until 1510, and not before he had executed the apotheosis of the situs figure in cat. 12a. —M.C.

THIS "TREE OF VESSELS" drawing is so highly inaccurate that, anatomically speaking, it is of little use in the modern world. With the exceptions of the courses of the cephalic and basilic veins in the upper extremities and the greater saphenous veins in the lower extremities, it is difficult to reconcile the inaccuracy of this image with Leonardo's precise observations of the skull, especially since the course of many of the superficial veins is visible through the skin. Some of this problem is due to the application of the anatomy of animals to humans. This drawing, for example, incorporates an ungulate pattern of branches of the aortic arch. Likewise, there is an animalistic arrangement of the kidneys. —R.P.

44

PART TWO
c. 1504–1509

And you who say that it is better to see a dissection performed than to see these drawings would be right, if it were possible to see all the things which in these drawings are demonstrated in a single figure. In [dissection], with all your ability, you will not see nor obtain knowledge of more than a few vessels, to obtain a true and full knowledge of which, I have dissected more than ten human bodies, destroying all other organs and taking away in its minutest particles all the flesh which was to be found around the vessels without causing them to bleed, except for the imperceptible bleeding of capillary vessels. And one single body was not sufficient for long enough, so that it was necessary to proceed little by little with as many bodies as would render a complete knowledge. This I repeated twice to observe the differences.

And though you may have a love for such things you will perhaps be impeded by your stomach; and if this does not impede you, you will perhaps be impeded by the fear of living through the night hours in the company of quartered and flayed corpses, fearful to behold. And if this does not impede you, perhaps you will lack the good draftsmanship which appertains to such a representation; and even if you have a skill in drawing, it may not be accompanied by perspective; and if it were so accompanied, you might lack the methods of geometrical demonstration and methods of calculating the forces and strength of the muscles; or perhaps you will lack the patience so that you will not be diligent. Whether all these things were found in me or not, the 120 books composed by me will give the verdict, yes or no. In these I have been impeded neither by avarice nor negligence but only by lack of time. Farewell.

RL 19070v, c. 1509

5A.

NOTES ON THE DEATH OF A CENTENARIAN

c. 1508
Pen and ink over black chalk, 7⁹/₁₆ ×
5⁹/₁₆ inches (19.2 × 14.1 cm.)
RL 19027v
K & P 69v; O'M & S 128

THIS SHEET OF NOTES was evidently compiled in three stages, over an abortive sketch in black chalk of the superficial vessels of the neck and arm. The second block of notes (lower left) describes the circumstances of Leonardo's best documented dissection:

> And this old man, a few hours before his death told me that he was over a hundred years old, and that he felt nothing wrong with his body other than weakness. And thus, while sitting on a bed in the Spedale di Santa Maria Nuova in Florence, without any movement or sign of any mishap he passed from this life.
>
> And I performed a dissection to see the cause of so sweet a death. This I found to be a fainting away through lack of blood to the artery which nourished the heart and other parts below it, which I found very dry, thin and withered. The dissection I described very diligently and with great ease because of the absence of fat and humors which greatly hinder the recognition of the parts. The other dissection was of a child of 2 years in which I found everything contrary to that of the old man.

A draft of the first block of notes, on Paris Ms. F, f. 1r, is dated Milan, 8th September 1508. The actual dissection must therefore have been carried out in the winter of 1507–8, when Leonardo was in Florence on legal business. Even without the evidence of dating, it would still be clear that this sheet, and the others from this period in Anatomical Ms. B (cats. 5a–10b), were not compiled during the course of a dissection. Rather, they are carefully considered reconstructions of internal forms, in the light of experimental evidence and of perceived function.

The reference to "the other dissection" implies that Leonardo had only carried out two dissections in these years, but on RL 19070v, probably of 1509, he stated, "To acquire a true and full knowledge . . . I have dissected more than ten human bodies." This is clearly not idle boasting, and should be taken as an accurate record of the extent of Leonardo's human investigation around the time of Anatomical Ms. B. —M.C.

ONLY A SMALL DRAWING of the hepatic portal venous system, minus the superior mesenteric vein, graces the top of this sheet. The anatomical bombshells are contained within the notes: the first records of cirrhosis of the liver, arteriosclerosis, calcification of vessels, coronary vascular occlusion, descriptions of changes with age in the appearance of veins, possibly a description both of caput medusae and aneurysm, and a very early usage of the term "capillary vessels." This is an astounding number of "firsts" in the history of medicine. Some of these have been attributed to other individuals who lived centuries later; this is perhaps due to the fact that Leonardo's works were unpublished and difficult to decipher. —R.P.

THE SUPERFICIAL VESSELS OF THE ARM

c. 1508
Pen and ink over traces of black chalk,
7⁹/₁₆ × 5⁹/₁₆ inches (19.2 × 14.1 cm.)
RL 19027r
K & P 69r; O'M & S 127; Philo et al.
118, 137; Woodburne 63

THE NOTE IN A DARK INK at the head of the page reads, "Portray the arm of Francesco the miniaturist, which shows many veins." This type of memorandum is frequently found in Leonardo's writings, and there is every reason to suppose that the main drawing is indeed taken from surface inspection of Leonardo's colleague, whose identity is otherwise unknown.

To the upper left is a note describing his intended illustrative procedure: "You will make the true contours of the limbs with a single line, and in the middle place the bones at their true distances from the skin . . . and you will make the veins which should be complete in a transparent field; and in this way, clear knowledge of the position of bone, vein and nerves will be given." Of course, such a prescriptive method is rarely followed to the letter.

The remainder of the sheet is given to comments on the nature of the veins, as on the verso of the sheet. "When the veins become old they lose the straightness of their branchings and become more folded or tortuous and the coverings thicken as old age increases with the years." Leonardo's cosmological musings are similarly expressed on Paris Ms. F, f. 1r, of the same period: "The spaces or cavities of the veins of animals, with the prolonged coursing of the humor that nourishes them, harden and finally close up. The hollows of the veins of the earth [e.g., rivers and subterranean streams] come to be enlarged through the long and continuous coursing of the water."

Leonardo's studies of water were at their most intense at this time, with the compilations of Paris Ms. F and the Codex Leicester (Hammer). His principles of fluid mechanics were the main scientific tools with which he attempted to elucidate the internal functions of the body around 1508–9. —M.C.

THE SMALL PAIR OF SKETCHES at the top center illustrate the configuration of veins in the young, at right, and the elderly, at left. The main drawing of superficial vessels of the left arm would be suitable for use in a modern atlas except for one point: Leonardo has shown an artery accompanying the large basilic vein crossing the axilla, but correctly has shown no artery with the cephalic vein on the lateral side of the arm. Leonardo had written a general rule stating, more or less, that veins were accompanied by arteries. In fact, one can note the mostly eradicated existence of an artery accompanying the cephalic vein close to its termination near the top of the drawing. The pattern of the structures accompanying the basilic vein is equine, but that of the cephalic vein is human. The brachial vein is not depicted. —R.P.

6A.

THE CARDIOVASCULAR SYSTEM

c. 1508
Pen and ink over traces of black chalk,
7⁹/₁₆ × 5¹/₂ inches (19.2 × 14.0 cm.)
RL 19028r
K & P 70r; O'M & S 119; Philo et al.
179–82; Woodburne 321–30

HERE LEONARDO ATTEMPTED to resolve the time-honored debate over the origin of the vascular system by an appeal to the analogy of a seed:

> All the veins and arteries arise from the heart, and the reason is that the biggest veins and arteries are found at their conjunction with the heart. . . . And if you say that the veins arise in the gibbosity of the liver because they have their ramifications in this gibbosity, just as the roots of plants have in the earth, the reply to this comparison is that plants do not have their origin in their roots, but . . . from that lower part of the plant which is situated between the air and the earth . . . Therefore it is evident that the whole plant takes origin from such a size, and in consequence the veins take their origin from the heart where they are biggest . . . and this is observed by experience in the sprouting of a peach which arises from its nut as is shown above at *ab* and *ac*.

Thus the diagrams at the upper left are labeled *core* (heart) and *noccolo* (nut).

The botanical analogy had a noble pedigree. Galen likened the liver and vessels to a dicotyledonous plant (an echo of which may be seen in the form of the liver in cat. 3b), with the heart as a fruit. Mondino claimed instead that the superior and inferior venae cavae "arise from the heart like the trunk of the tree," thus asserting the primacy of the heart, and it was this comparison that Leonardo accepted. It must be remembered that in Leonardo's eyes the analogy was not merely a neat trick, but a very real piece of evidence.

—M.C.

THESE STUDIES OF THE VASCULATURE of the thorax and upper abdomen are partly human, partly animal, and only partly accurate. Merely the outline of the heart is shown. Errors include exact symmetry of the venous and arterial trunks, the pattern of vasculature in the left arm (see cat. 5b), the perfectly midline azygous vein, and entrance of the right pulmonary vein into the vena cava at the letter *m*. Such errors are multifactorial in origin. In the fifteenth century, the heart was represented with only the two chambers we currently call ventricles; today we consider the

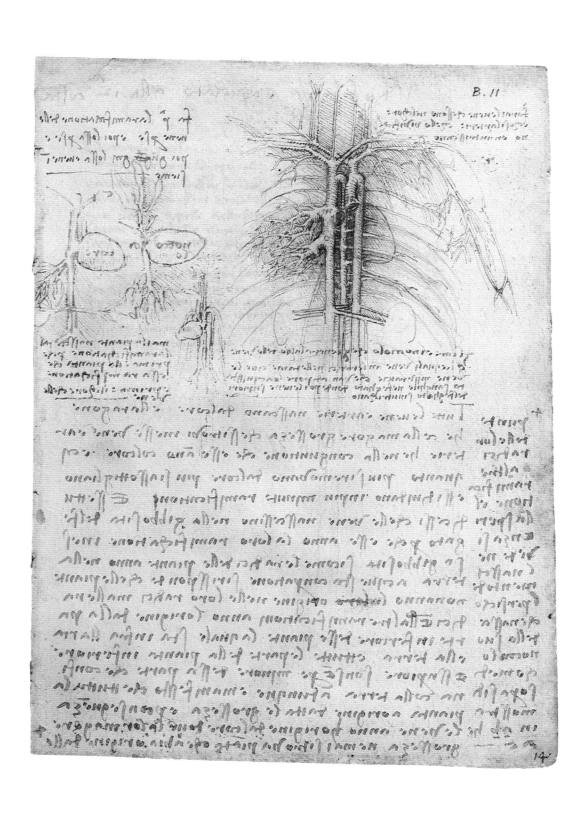

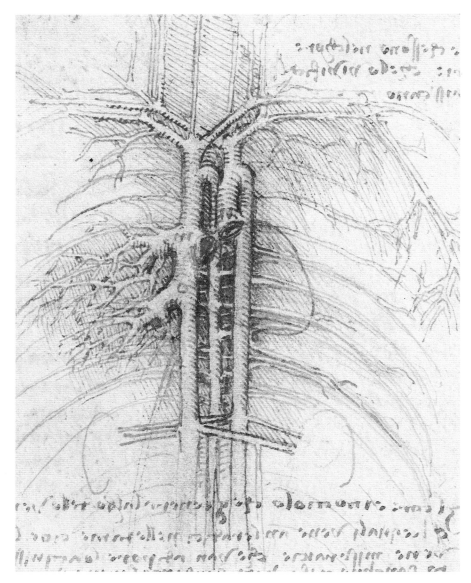

Detail of cat. 6a.

heart to have four chambers. The two chambers we call atria were considered to be enlargements or dilations of veins. Circulation of the blood was not clearly elucidated for 130 years after this drawing. When one combines these facts with the pressing problems impeding human dissection, the reasons for errors in illustrations and the use of animals in anatomy becomes clear. Of historical interest in this drawing is Leonardo's decision that vessels arise from the heart, following Aristotle, not the liver, following Galen. Leonardo appears to have graduated from Galenic to Aristotelian philosophy over the course of his studies. —R.P.

6B.

THE LIVER, SPLEEN, AND ASSOCIATED VESSELS

c. 1508
Pen and ink over black chalk, 7⁹/₁₆ ×
5¹/₂ inches (19.2 × 14.0 cm.)
RL 19028v
K & P 70v; O'M & S 129; Philo et al.
210–12, 218–19

THE INCREASING COMPLEXITY and assurance within this series of drawings reveal Leonardo's determination to make sense of a set of poorly understood dissection notes, in the light of accepted theory on the humors. Leonardo considered that "it is impossible to remove the spleen from men . . . without death, and this happens because of the veins with which it nourishes the stomach." Here he probably alluded to the legend that the ancient Greeks performed splenectomy on their athletes, to prevent them getting a stitch.

The careful draftsmanship of the lower right drawing, with meticulous hatching and a minimum of black chalk underdrawing, shows that Leonardo was satisfied with this arrangement of the vessels. He carried over the system unchanged into the great female situs figure (cat. 12a), the epitome of his work on the internal organs.

—M.C.

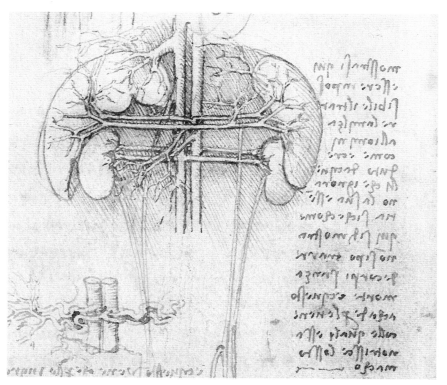

Detail of cat. 6b.

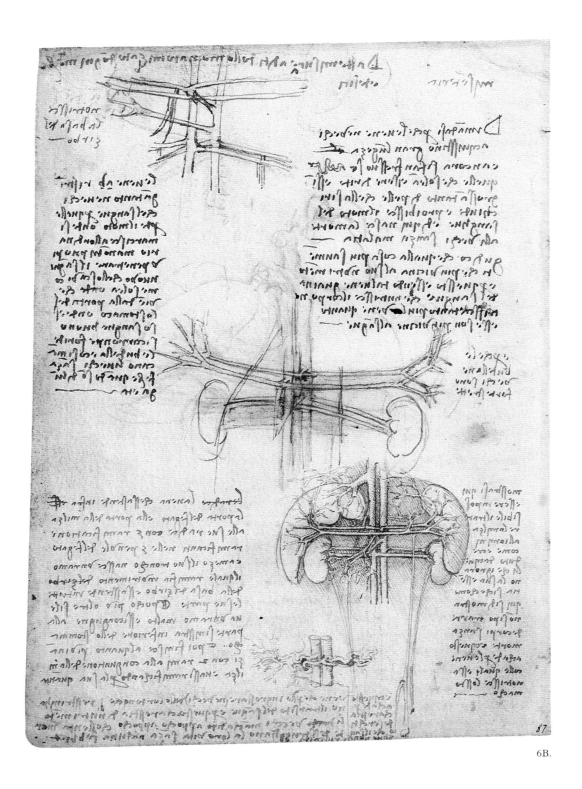

6B.

LEONARDO HERE CONTINUED his interest in the hepatic portal venous system and age changes within the portal system from cat. 6a. Animal dissections, coupled with what may have been a desire to illustrate the physiology of the era, have resulted in incorrect sizes and relations of the liver and spleen. Short gastric veins are exaggerated, the superior mesenteric and inferior mesenteric veins are disproportionate, and Leonardo discussed a five-lobed liver—distinctly non-human.

— R. P.

7A.

THE ALIMENTARY TRACT AND SUBDIAPHRAGMATIC ORGANS

c. 1508
Pen and ink over traces of black chalk,
7⁹/₁₆ × 5⁷/₁₆ inches (19.2 × 13.8 cm.)
RL 19031v
K & P 73v; O'M & S 185; Philo et al.
197–213

BEYOND THE RECEIVED WISDOM on the humors, Leonardo's considerations of the alimentary system were couched almost solely in physical terms; his interest in chemistry extended no further than a sweeping dismissal of alchemists and "other magicians." An illustration of the intestines prompted a typical piece of comparative physiology, between a snake and a man:

> Animals without legs have a straight bowel, and this is because they stay horizontal . . . but in man . . . through his standing so erect, the stomach would immediately empty itself if the tortuosities of the intestines did not slow down the descent of food; and if the bowel were straight each part of the food would not make contact with the bowel as it does in tortuous bowels.

In a convoluted note at the upper left, scattered with crossings-out as the normally lucid Leonardo struggles to express himself, he contends further that evacuation is caused by pressure exerted by the diaphragm and anterior abdominal wall during respiration. The passage is clarified on a slightly later sheet, RL 19065v: "This flux and reflux of the two powers created by the diaphragm and the abdominal wall are those which compel the stomach to intermittent expulsion." The clear distinction drawn by Leonardo between the caecum and appendix testifies to his use of human material—in particular the "centenarian"—at this time, though his physiology is purely speculative: "The auricle *n* [appendix], of the colon *nm*, is a part of the monoculus [caecum] and is adapted to contracting and dilating so that superfluous wind should not rupture the monoculus." —M.C.

ALTHOUGH THE MOST PROMINENT features of this sheet are continued views of the contents of the abdomen, the small figure on the bottom right is the most important anatomical representation, for here is presented the first illustration of the appendix. The ileum can be seen entering from the right with the appendix at *nr* and the caecum at *mr*. One is first tempted to criticize the caecum for being disproportionately large, but

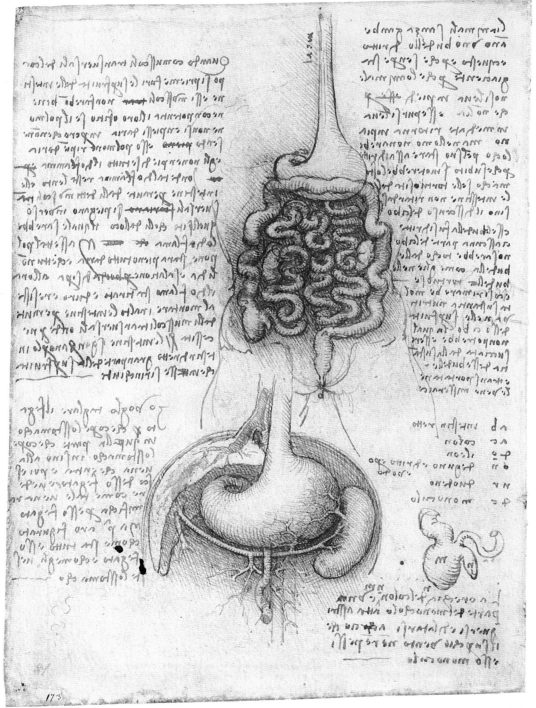

caecums of great size are routinely encountered in the laboratory. With regard to the top center figure of the stomach and intestines, somewhat schematized, the kidneys are indicated, even if a little out of position. The study could have been based upon the centenarian. Leonardo had already commented upon the empty and contracted nature of the gut; therefore the smallness of the bowels may relate to that fact as much as to a schematization. All humans are endowed with the same basic morphological plan, but volumes have been written on the variations to this plan. Leonardo could not anatomize a sufficiently large number of subjects to begin to see the possible variations in structure, and he may have mistakenly concluded that all individuals are exactly alike, except for size and proportion of their components.

Leonardo never observed peristalsis, the waves of muscular contraction that move the contents through the gut and ureters. Only the processes of gravity, action of body wall musculature, and propulsion by gas were envisioned by Leonardo for movement of the gut contents. He appears to describe accurately the Valsalva maneuver, a lowering and fixation of the diaphragm in conjunction with contraction of body wall musculature to aid in defecation.

Little is added to previous drawings by the view of the stomach, liver, spleen, and hepatic portal system. The organs are more in proportion, the inferior mesenteric vein is absent, and, possibly, the superior mesenteric artery is shown emerging from beneath the stomach and crossing the splenic vein.

—R.P.

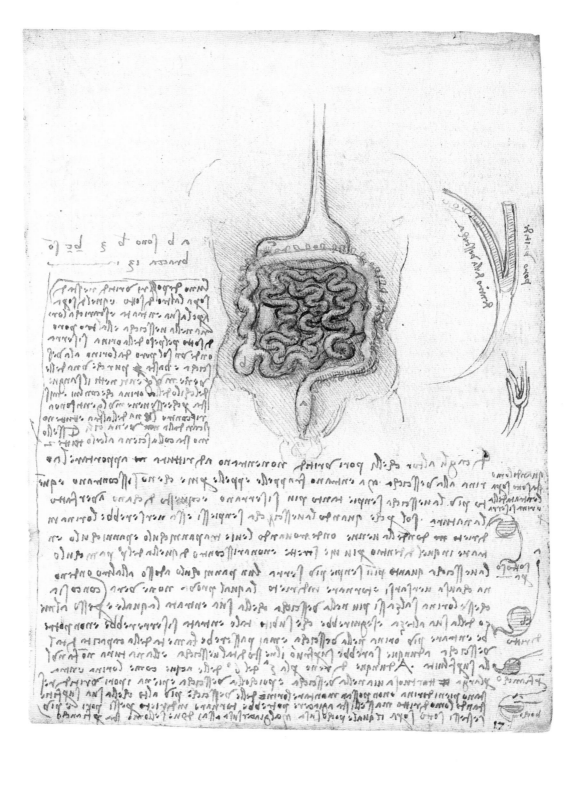

THE ALIMENTARY TRACT, AND THE HYDROSTATICS
OF THE BLADDER

c. 1508–9
Pen and ink with wash, over traces of
black chalk, 7⁹/₁₆ × 5⁷/₁₆ inches
(19.2 × 13.8 cm.)
RL 19031r
K & P 73r; O'M & S 192; Philo et al.
197–213; Woodburne 242

THE SUBJECT OF THE main illustration is essentially that of the reverse of the sheet (cat. 7a). The whimsical meanderings of the intestines, arranged in the plane of the sheet, with plenty of space between the coils, and in a different order from the illustration on the verso, emphasize the lack of a one-to-one relationship with dissection material. Nevertheless, Leonardo has measured the intestines during a dissection and records, "*ab* [colon] is 3 *braccia*, *bc* [small intestine] is 13 *braccia*." The *braccio* was an old Italian unit of measurement, literally an arm, roughly equivalent to two modern feet— we continue to use units derived from the body's proportions.

The remainder of the sheet is given to a consideration of the hydrostatics of the bladder, in particular the valvular action at the lower end of the ureter to prevent reflux of the urine, for various positions of the body. After a refutation of the traditional theory that "the ureters enter between skin and skin by ways that do not meet each other, and the more the bladder fills the more they are closed," Leonardo explained his concepts in terms of his own work on fluid mechanics (see cat. 8a):

> We shall tell by the 5th [rule] of the 6th [chapter of] *On Water* how urine enters the bladder through a wide and tortuous passage, and how when the bladder is full the uretic passages remain full of urine . . . Where a man lies on his side, one of the ureters rests above, the other below, and that which is above opens its entrance and discharges urine into the bladder, and the other duct below is closed by the weight of the urine.

The small sketches in the lower right margin demonstrate the relative positions of bladder and ureters for various postures. The squeezing-in of their explanatory note, continuing at the upper left and spilling over onto the margin of RL 19030v, makes it clear that it was compiled after the main diagram. The hydrostatic content, dependent upon Leonardo's work of 1508–9, and two teleological statements— "This nature has done solely because . . ." and "Nature makes nothing superfluous . . ."—suggest that the notes were added later in 1509, or even in 1510, after Leonardo had made contact with Marcantonio della Torre (see the introductory essay).

—M.C.

APPENDICES EPIPLOICAE, small fat-filled tabs, are shown along the course of the ascending, transverse, and descending colon; this feature is diagnostic for the large bowel. The appendix is absent from the ileocecal junction at *d*; perhaps it is in a retrocecal position behind the caecum, a circumstance that even today may baffle physicians in the correct diagnosis of appendicitis.

Leonardo was aware of the ureters' oblique course through the bladder wall to form a flap valve, but since he was unaware of peristalsis, he theorized the physiology only from the viewpoint of gravity. —R.P.

8A.

"DEMONSTRATION OF THE BLADDER OF MAN"

c. 1508–9
Pen and ink over black chalk, 7⁵/₈ ×
5⁵/₈ inches (19.4 × 14.2 cm.)
RL 19054r
K & P 53r; O'M & S 190; Philo et al.
238, 242; Woodburne 485–88, 500–505

AS ON CAT. 7B, this sheet consists of a main illustration (here three diagrams of the bladder) with anatomical notes, followed by a later text (at lower right) on the fluid mechanics of the urine.

 The earlier part of the sheet is unusually calm and self-contained for this stage of Leonardo's researches. The drawings are entitled "Demonstration of the bladder of man," and their features are described below:

First demonstration [upper left]

Of these three demonstrations of the bladder, in the first is drawn the ureters and how they leave the kidneys *Lh*, and are joined to the bladder two fingers higher than the beginning of the neck of the bladder; and a little inside this junction these ureters pour urine into the bladder from *pb* into *nf* in the way drawn at the side in the channel *s*, whence it is poured through the pipe of the penis *ag* . . .

Second demonstration

In the second demonstration are drawn the four ramifications, that is right and left of the veins which nourish the bladder, and the arteries, right and left, which give it life, that is, spirit—and the vein always lies above the artery.

Third demonstration

In the third demonstration is described the way the vein and artery go round the origin of the ureter *mn* at the position *n* . . .

 The roundness of the bladder is delicately conveyed by a combination of the curved hatching on the subject with the straight parallel hatching of the background (compare this with the uniformly straight hatching of cat. 2). The purpose of the extensive black chalk drawing under the central diagram is not known.

 The later note is similar in content to that on cat. 7b. Reference here is made to the "4th [section of] *On Conduits*, where it says: water which descends from a height through a narrow vessel and penetrates under the bottom of a lake cannot be opposed by reflected movement, unless the water of the lake is equal in size to that in the vessel which descends; nor from a greater height of the water than the depth of the lake."

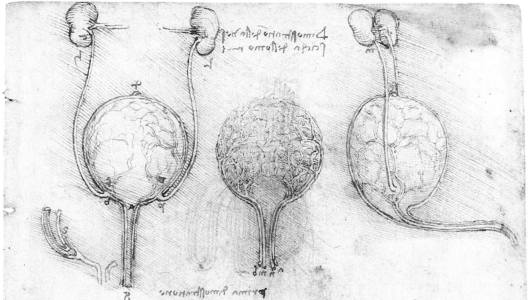

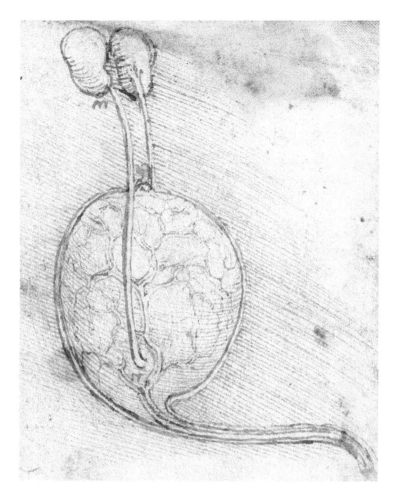

Detail of cat. 8a.

Although *On Conduits* is listed as one of the divisions of the treatise *On Water* in the Codex Leicester (Hammer), f. 15v, the "rule" is not to be found in this form in the vast body of observations which make up the majority of that manuscript. Several other untraceable references to a treatise on water scattered through Leonardo's late notes suggest that another, possibly more organized, tract was compiled at about the time of the Codex Leicester, c. 1508–9, but is now lost. —M.C.

THREE VIEWS OF THE urinary bladder and urethra, with kidneys and ureters shown on the first and last, are the major diagrams, but on the left is a smaller diagram, again representative of Leonardo's concern with the flow of urine and the filling of the bladder. Arterial supply and venous drainage are shown for the bladder and the urethra, but errors mar the validity of the first two of the three bladder figures. The main supply and venous drainage are derived from the vessels above and to the sides of the bladder. Here, Leonardo has either confused vessels of the bladder as arising from and connected with those of the penis, or he has followed an anastomosis or connection between a major vessel, the superior vesical artery, with a minor one, perhaps the deferential artery. On the third drawing, however, Leonardo must be commended for fine dissection and observation by notation of a vascular corona around the entrance of the ureter into the bladder. —R.P.

THE LUNGS AND OTHER VISCERA

c. 1508
Pen and ink with touches of wash, over
traces of black chalk, 7⁵/₈ × 5⁵/₈ inches
(19.4 × 14.2 cm.)
RL 19054v
K & P 53v; O'M & S 171

THE LUNGS HELD LITTLE interest for Leonardo. Their role in medieval physiology was relatively minor, being a device to regulate the innate heat produced in the heart: "This heat subtilizes the blood and vaporizes it, and . . . it would convert some of it into the element of fire if the lung, with the freshness of its wind, did not relieve such an excess" (RL 19081r, c. 1513).

Here Leonardo concerned himself instead with the structure of the lungs, subject to the basic Aristotelian principles of fluid flow in a branching system. In modern terms, these state that velocity of flow is inversely proportional to cross-sectional area, for a constant rate of flux; and that to avoid turbulent flow, the velocity must be constant within the system. Thus the total cross-sectional area must be preserved at each level of branching, a law that Leonardo applied here to the structure of the lungs (in both transparent and superficial views), and in Paris Ms. M, f. 78v (c. 1500, fig. 18) to the growth of a tree. Elsewhere, Leonardo also argued that "variation of

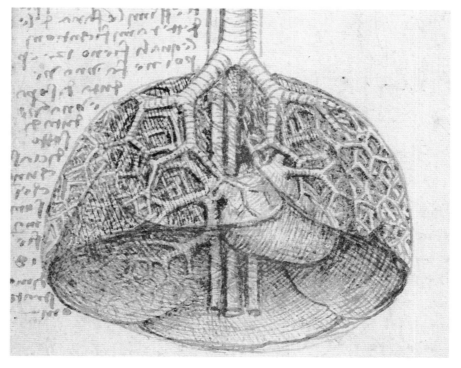

Detail of cat. 8b.

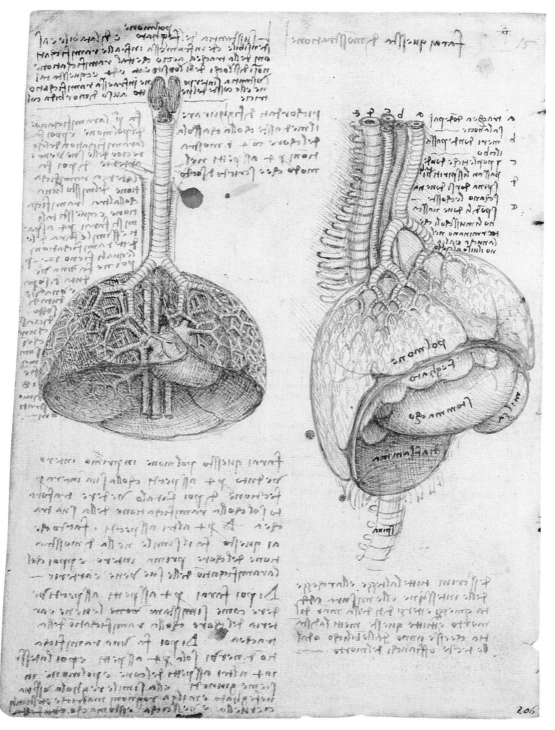

the voice arises from dilatation and constriction of the rings of which the trachea is composed'' (RL 19050v), these constrictions causing turbulent flow in the trachea.

The present sheet appears to be based on the dissection of a pig, a common subject for investigation throughout the history of anatomy. Galen had experimented on the recurrent laryngeal nerve of a squealing pig, and in a direct reference to this, the figurated capital Q in Vesalius's *De humani corporis fabrica* shows a group of studious putti cutting into the throat of a hapless chained-down swine. On RL 19034r, contemporary with the present sheet, Leonardo states that "the enlargement of the lung when it is filled with air is latitudinal and not in its length, as can be seen by inflating the lung of a pig," possibly the same specimen as that illustrated here. —M.C.

LEONARDO'S DISSECTIONS of the pig were good preparation for his human studies. They allowed him to perfect and develop his "fenestrations" and gain perspective. These particular drawings, however, advance nothing for human anatomy but again show a concern for symmetry. When we realize the difficulties in dealing with unembalmed and thus unhardened material, it is understandable how these structures could appear out of position. —R.P.

Fig. 18
Leonardo da Vinci, *The branching of trees*. Pen and ink. Paris, Institut de France (Ms. M, f. 78v).

9A.

"THE MOTOR MUSCLES OF THE LIPS OF THE MOUTH"

c. 1508
Pen and ink over black chalk, 7⁹/₁₆ ×
5⁵/₈ inches (19.2 × 14.2 cm.)
RL 19055v
K & P 52v; O'M & S 180; Philo et al.
34, 37–38

UNDERSTANDABLY, THERE WAS no medieval tradition to distract Leonardo in a treatment of the muscles of the lips. The absence of any wider significance within the systems of the human body, or within the material or spiritual universe, made the subject thoroughly uninteresting for his predecessors. This is, therefore, one of the few subjects in Anatomical Ms. B to be approached in a wholly underivative manner.

The facial muscles were of course of great concern to artists, and in particular portraitists: witness posterity's fascination with the smile of Mona Lisa del Giocondo, whose portrait Leonardo had begun a few years earlier in Florence. The present study is clearly derived principally from surface examination of a living subject, with small measures of intuition and dissection (cf. cat. 18b). A discordant note is struck by a short passage within the extensive text, which deals with proportional matters much more typical of the years dating to about 1490: "The maximum shortening of the mouth is equal to half its greatest extension, and it is equal to the greatest width of the nostrils, and to the interval between the lachrymal ducts of the eyes."

The unrelated drawing at the center right is a preliminary sketch for the studies of the uterus of a gravid cow, fully worked up on the recto of the sheet (the stitch-marks on the right edge of the paper reveal how the sheets were sewn together into notebook form, thus distinguishing recto from verso). This phenomenon, of material on the verso of a sheet preceding that on the recto, occurs throughout Leonardo's manuscripts: his left-handedness occasionally led him to compile material from the back of a notebook towards the front, just as it was natural for him to write from right to left. — M.C.

THESE MOUTH AND LIP drawings are accompanied by typical Leonardesque notes on function. Although the buccinator muscle may be represented on the two drawings, one above the other at the lower right margin, the orbicularis oris, a major muscle of the lips, is not seen. We are reminded of the notebook nature of these sheets by the presence of a study of a fetal cow in the womb, just above the bottom four oral studies. — R.P.

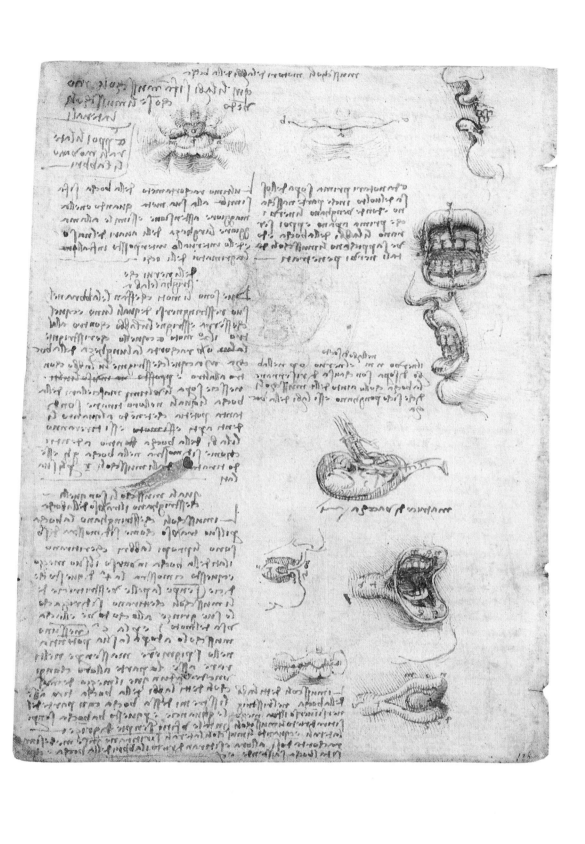

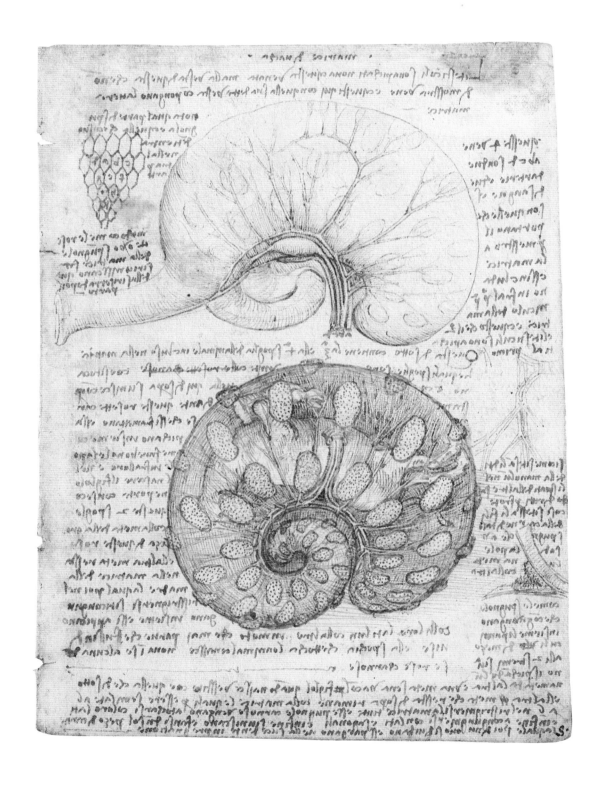

"THE UTERUS OF THE COW"

c. 1508
Pen and ink over traces of black chalk,
7⁹/₁₆ × 5⁵/₈ inches (19.2 × 14.2 cm.)
RL 19055r
K & P 52r; O'M & S 211

THIS SENSITIVE SHEET investigates the fetal calf within the bicornuate uterus of the cow. It is evident that Leonardo has scraped away much of the black-chalk underdrawing of the upper illustration, adding only fine outlines and hatching to give a delicacy quite opposed to the vigorous modeling of cat. 22a.

The sheet is principally concerned with the fetal membranes, in particular the system of interdigitating cotyledons. The text surrounding the lower drawing, which shows a transparent chorion enclosing the fetal calf, reads:

> This [diagram] below contains the 3rd and 4th sloughed membranes [chorion and amnion] of the animal enclosed in the uterus. These are united, that is they are in contact, and that which is superficial is united with [the uterus] through these fleshy rosettes which interlock and stick together, as burrs do with each other. And at birth the infant carries with it these two membranes with half the thickness of the roses, and the other half remains in the uterus of the mother, which then in contracting rejoins, with their sides attached in such a way that they would appear never to have been separated. And the sloughed membrane in contact with the animal which is born has none of these fleshy roses.

Believing the uteri of all animals to be essentially the same, the notes refer not to cow and calf, but to mother and infant, and the results of this investigation were to be applied (mistakenly) to the human fetus a couple of years later.

It is immediately apparent from the diagrams that Leonardo appreciated the natural geometry of the structure. The recurrence of the spiral or vortex throughout Leonardo's work in the last two decades of his life has been noted repeatedly, and here the lower diagram has been stylized, possibly subconsciously, to resemble a shell or fossil in its general outlines. The distribution of the cotyledons on the surface must also have prompted comparisons with the seeds of a sunflower or the spines of a pine cone. This circular-hexagonal or logarithmic spiral motif became a common decorative feature in the sixteenth century, used, for instance, by Michelangelo for the pavements of the Piazza del Campidoglio and the Biblioteca Laurenziana. —M.C.

THE FAME OF LEONARDO as a comparative anatomist could rest upon this drawing of a gravid cow uterus. For orientation, the vagina, or "down," is to the left margin. Humans have a single uterus, but cattle have two uterine horns, a condition termed bicornuate. Only one is gravid in this specimen; the other non-gravid horn, greatly reduced in size, gently curves away from the vagina beneath the gravid horn. Uterine vessels are shown as well as the ovaries, called "testicles" by Leonardo. The ovary

associated with the gravid uterine horn is the most clearly seen, along with its associated ligaments. On the upper drawing, the uterine wall is opaque, but on the lower figure the wall has been removed, and the calf fetus, head to the left, can be seen through the chorionic membrane.

For further appreciation of this drawing, one must understand a small bit of comparative anatomy. Cattle possess a cotyledonous form of placenta—these are the "rosettes" or "little sponges" that are seen through the uterine wall on the uppermost drawing and on the surface of the chorion on the lower drawing—rather than a solitary discoidal form as in the human. Leonardo has not only correctly shown these structures, he has illustrated how they make contact with the maternal tissue—note the small drawing, lowermost along the right margin—"just as the fingers of the hand are interwoven, one in the interval of the other, lying straight and facing, so the fleshy villi of these little sponges are interwoven like burrs, one half with the other." What a tremendous observation and explanation! The drawing on the top left is not a prediction of the invention of chicken wire, but a visual description of how the separate cotyledons are squeezed together by the uterus after parturition in order to be expelled in one piece. —R.P.

10.

THE OPTIC CHIASMA AND RELATED CRANIAL NERVES;
THE UTERUS AND ITS BLOOD SUPPLY

c. 1508
Pen and ink over traces of black chalk,
with scratching-out, 7¹/₂ × 5³/₈ inches
(19.0 × 13.6 cm.)
RL 19052r
K & P 55r; O'M & S 148; Philo
et al. 22–26, 45–46; Woodburne 218;
Moore 326–27

IN A PARTICULARLY FRUITFUL reprise of his earlier studies, about 1508 Leonardo devoted several sheets to an investigation of the brain. Abstract speculation on the location of the mental faculties was replaced by conclusions drawn from painstaking dissection. Inevitably, the results were much more substantial than those from the work about 1490.

Leonardo described his dissection technique in the block of text at the center and left:

> Ease away the brain substance from the borders of the dura mater which is interposed between the basilar bone and the brain substance. Then note all the places where the dura mater penetrates the basilar bone with the nerves ensheathed in it together with the pia mater. And you will acquire such knowledge with certainty when you diligently raise the pia mater, little by little, commencing from the edges and noting bit by bit the situation of the aforesaid perforations, commencing first from the right or left side, and drawing this in its entirety. Then you will do the opposite side which will give you knowledge as to whether the previous one was correctly situated or not, and further, you will come to understand whether the right side is the same as the left. And if you find differences, review the other dissections to see whether such a variation is universal in all men and women, etc.

The optic chiasma had been described by Mondino, whose *Anathomia*, or a derivative treatise on optics, was probably the source of Piero della Francesca's awareness of the structure: "The eye, I said, is round and from the intersection of the two nerves which cross comes the power of vision at the center of the crystal fluid" (from *De prospectiva pingendi*, c. 1485). There is no evidence that the painter, a generation older than Leonardo, ever performed a dissection himself. —M.C.

THE SKULL WITH ITS ANTERIOR, middle, and posterior fossae is represented, and the eyes can be seen through holes in the orbital roof plates. The optic nerves proceed posteriorly, encounter the chiasma, or X-shaped structure, and the optic tracts continue posteriorly from there. The olfactory lobes and nerves are clearly seen. Next are a series of structures including the oculomotor nerve and the abducent nerve. This commentator on Leonardo may disagree with his predecessors in saying the trochlear nerve, cranial nerve IV, may be present—and Leonardo's notes are no help in this matter. The ophthalmic, maxillary, and mandibular divisions of the trigeminal

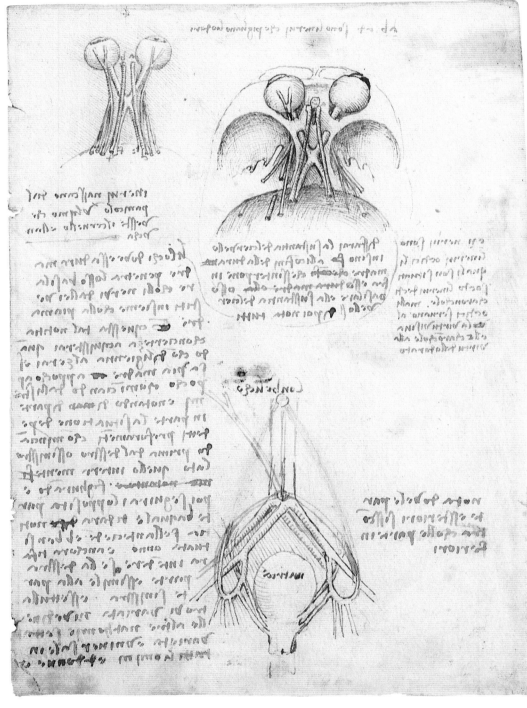

nerve are seen on each side as finger-like projections pointing anteriorly within the middle cranial fossa. If Leonardo saw the ganglion of the trigeminal nerve, he neither illustrated it nor discussed it. The orbit contains many structures packed into a small volume, and it is not surprising that Leonardo may have encountered some difficulties here in his illustration, and we in its interpretation.

A drawing of the uterus and vessels on the lower part of the page should not be dismissed as unimportant. Here is represented the formation of the inferior vena cava from the common iliac veins (on the left) and the bifurcation or division of the aorta into the common iliac arteries. The umbilicus, originally drawn too high, has been lowered to its proper position. Most important in this drawing are the structures associated with the umbilicus. In several places within Leonardo's drawings, he pictures the ligaments—actually obliterated fetal vessels and ducts—but invariably does so incorrectly (see cat. 12a). Not so in this drawing. Observe the internal iliac artery with several branches—the number, as well as their depiction, varies even today—supplying the uterus. Finally, note the superior vesical arteries curving to each side and then arching up to converge upon the umbilicus. These are the obliterated umbilical arteries. While once they transported low oxygen blood towards the placenta, here they are termed medial umbilical ligaments because they lost their lumen after birth. From the umbilicus, one can see the ligamentum teres hepatis at the upper left side of the drawing, the remnant of the umbilical vein, a former conduit of oxygenated blood returning from the placenta. —R.P.

11.

THE CEREBRAL VENTRICLES

c. 1508
Black chalk and pen and ink over
black chalk, 7⁷/₈ × 10⁵/₁₆ inches
(20.0 × 26.2 cm.)
RL 19127r
K & P 104r; O'M & S 147

ON THIS SHEET LEONARDO returned to the problem of the ventricles of the brain and the localization of the mental faculties. In a brilliant and original investigation, he used his sculptor's skill to make a wax cast of the ventricles, the first recorded use of a setting injection medium to determine the form of a body cavity. He described the procedure at the upper left: "Make two vent-holes in the horns of the greater ventricles, and insert melted wax with a syringe, making a hole in the [fourth] ventricle of memory; and through such a hole fill the three ventricles of the brain. Then when the wax has set, take apart the brain, and you will see the shape of the ventricles exactly."

This concrete evidence failed to resolve Leonardo's earlier quandary over the siting of the faculties. On the diagram at the upper left he has labeled the lateral ventricles *imprensiva*, the third ventricle *senso comune*, and the fourth *memoria* (see cat. 1a for an explanation of these terms). But this arrangement, which would involve all the sensory nerves passing through the *imprensiva* of the lateral ventricles, was clearly at odds with the observation at the lower right which noted "since the [fourth] ventricle *a* is at the end of the spinal cord . . . we can judge that the sense of touch passes into this ventricle."

A marginally later sheet (fig. 19), originally part of Anatomical Ms. B but now in Weimar, shows the brain sited within the head, with the ventricles labeled as on the present sheet. But the nerves pass to the base of the brain with a distribution unrelated to the depicted ventricles; the tension between observation and theory is clear. And in what is possibly Leonardo's last drawing of the configuration (c. 1509, fig. 20), nerve pathways are shown attached to all parts of the ventricular system, with no attempt to assign the mental faculties, either explicitly or implicitly.

Judging by the frequency with which sketches of the ventricular cast occur in Leonardo's manuscripts at this time, he was both highly satisfied with the success of the experiment, and yet unable to use the combined results of the cerebral investigations to distribute the faculties. This refusal to distort material evidence in order to harmonize it with abstract speculation heralds Leonardo's maturity as an anatomist. In the osteological and myological investigations of Anatomical Ms. A which followed, material evidence was to be the sole guide. —M.C.

PHYSIOLOGY DURING LEONARDO'S era stressed the fluid-filled ventricles of the brain as the site of brain activity. These ventricles were depicted by most artists in views more conceptual than actual. Consider the difficulties that hampered the accurate dissection and depiction of what is, for all purposes, a cave system filled with fluid but imbedded in an unembalmed brain whose substance has the consistency of warm gelatin.

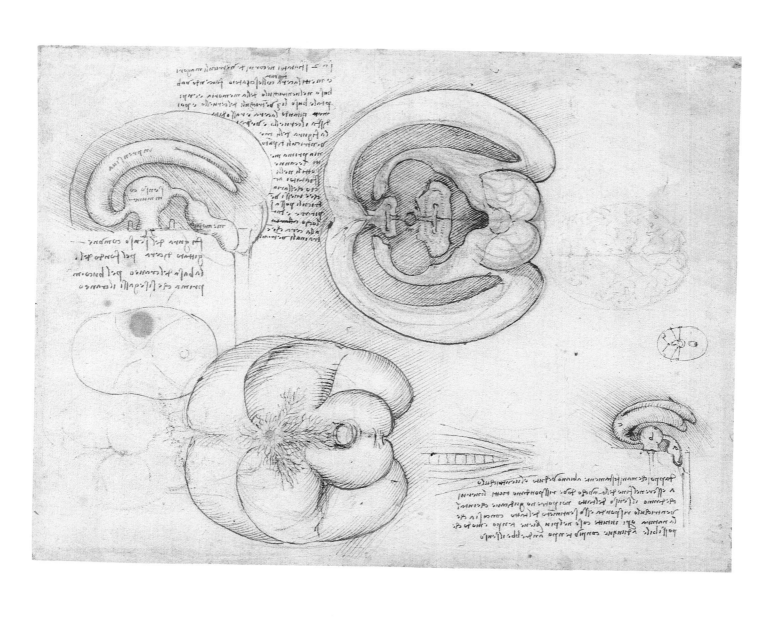

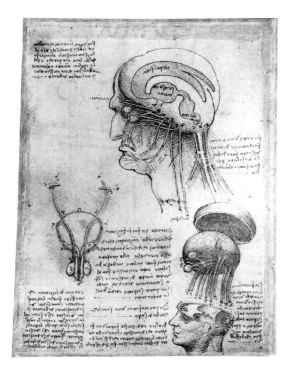

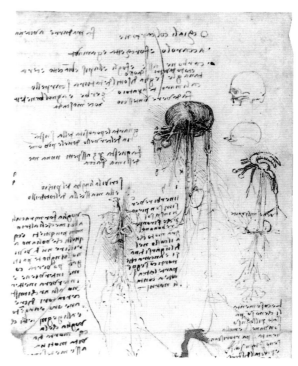

Leonardo devised a simple but novel solution to this problem: use the ventricular system as a mold and fill it with a solution—hot wax—that will harden. Then, one could pull the brain tissue away and examine a solid cast of the ventricles. Ventricular casts of an ox brain are depicted in the series of drawings from the top left to bottom right. The lateral views, at the upper left and lower right, depict fairly accurately the lateral ventricles, the foramina of Monro, the third ventricle, the cerebral aqueduct, and the fourth ventricle; a continuity with the central lumen of the spinal cord is shown in the upper left drawing. The drawing at the upper center could represent a unique view looking down on the superior surface of the brain after the brain has been cut in the midline and opened like a book. Thus the third ventricle and cerebral aqueduct have been divided longitudinally and appear on both sides, but the cut has only proceeded to the middle of the fourth ventricle. Other drawings on the page are of the inferior surface of the brain, with a feathery structure surrounding the area of the pituitary gland. This is a rete mirabile, not found in the human, which serves to equalize and maintain intracranial blood pressure in large animals whose heads may lower or raise rapidly. To the right of the drawing of the inferior surface of the brain is another drawing, either of the floor of the fourth ventricle, or possibly of the vermis of the cerebellum. A faint drawing at the upper right is of the contours of the superior aspect of the ox brain. Two smaller drawings, at the center right and center left, appear to be sketches of the floor of the cranial cavity.

Aside from the brilliant scheme to depict the ventricles, and the magnificent representations Leonardo has drawn, the question remains as to what species is really depicted here. Leonardo writes that he used the ox, in all probability a castrated specimen of the ungulate *Bos taurus*. However, the configuration of the brain and ventricles drawn on the page is human. In the ungulate, the cerebellum is placed more posteriorly to the cerebrum than beneath it, and there is little change in angle where the spinal cord

joins the brain stem, and little change in direction of the brain stem. As a result the central canal of the spinal cord, fourth ventricle, and cerebral aqueduct are somewhat positioned in a straight line. The brains and ventricular casts drawn on this sheet demonstrate the cervical and cephalic flexures typical of the human brain—a consequence of erect, bipedal posture; the cerebellum is located mostly beneath the cerebrum. The third ventricle in ungulates is doughnut-shaped because of a large intermediate mass, but the third ventricle in this case is solitary, as may be found in humans whose intermediate mass is small and may not form an interthalamic adhesion. Yet the rete mirabile and surface contour sketch are not human. Has Leonardo imposed his knowledge of the ox brain upon a human brain? Has he dissected human brains and filled them with hot wax? Has he dissected both and drawn an amalgam of the best dissections of human and animal to represent the human? This last possibility may well be the case.

<div align="right">—R.P.</div>

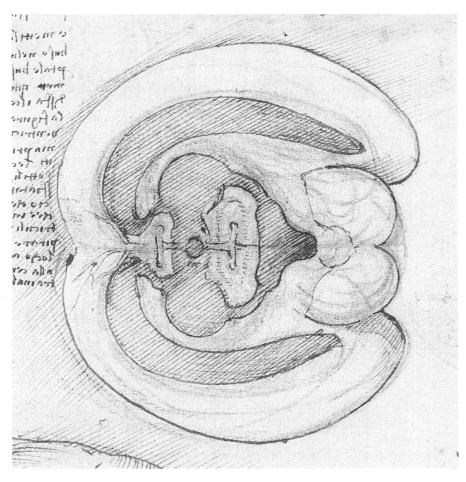

The brain, sagitally sectioned and opened out: detail of cat. 11.

THE FEMALE VISCERA

c. 1509
Recto: pen and ink, over black chalk and
traces of red chalk, with ocher wash,
pricked for transfer; traces of charcoal
around prick holes. Verso: blank.
18³/₈ × 13¹/₈ inches (46.7 × 33.2 cm.)
RL 12281r–v
K & P 122r–v; O'M & S 202; Philo
et al. 322, 382, 480

THIS POWERFUL, HEAVILY worked drawing is the culmination of Leonardo's studies of the viscera contained in Anatomical Ms. B and hence is probably datable to 1509. Several structures are carried over unchanged from the pages of that notebook: the trachea and bronchi from cat. 8b, the liver, spleen, kidneys, and associated vessels from cat. 6b, and so on. A combination of representative methods is used, echoing those of the preceding period (transparency, sectioning, positioning within an outline) and anticipating some from Anatomical Ms. A, such as the use of wash modeling.

In addition, the sheet is riddled with pinholes. The process of pricking and pouncing was widely used during the Renaissance to permit the mechanical transfer of the outlines of a drawing. Small holes were pricked along the outlines, then charcoal dust was pounced through from a muslin bag, to leave dotted lines on the secondary surface. An intermediate sheet was sometimes made by pricking it through with the original. The charcoal in and around the holes shows that the present sheet was used for pouncing at some stage.

The status of the sheet as a working drawing, which explains the extensive reworking and confusion of technique, allows one to reconstruct the stages through which the drawing passed. An initial rough sketch in black chalk of the body's outlines and diaphragm was made. The sheet was then folded along the vertical axis, and pricked through with a broad pin, to create a symmetrical framework for the viscera. With touches of black chalk, red chalk, and a narrow pen, the viscera and principal vessels were drawn in and isolated with light hatching (the spherical uterus, and identically sized but ambiguously placed bladder, were constructed with compasses). Then with a broader pen, the outlines of the body were redrawn, the liver reinforced, the spleen and portal and hepatic veins moved, and the umbilicus added. The finer ramifications of the vessels were inked in on the right side of the body only.

The sheet was folded again, and the pricking-through of the details commenced. At this stage the paths of the ureters were adjusted and the umbilicus was lowered. Leonardo mistakenly pricked through the outlines of the liver onto the left side, but the sheet was unfolded before he pricked the heart and spleen. The left kidney remained unpierced. Upon unfolding, the outlines of the uterine vessels were strengthened, and the abdominal structures more heavily hatched. Finally, an ocher wash was added to isolate and model the viscera and some of the vessels.

Fortunately, a partial copy made from this sheet survives (fig. 21). It was certainly executed by Leonardo himself; it is not an abortive attempt at a full copy, but is solely concerned with clarifying the positions of the vessels, especially in the abdomen. The imaginary "menstrual veins" are now visible, winding their way up from the uterus to the breasts, as first depicted by Leonardo on cat. 3a.

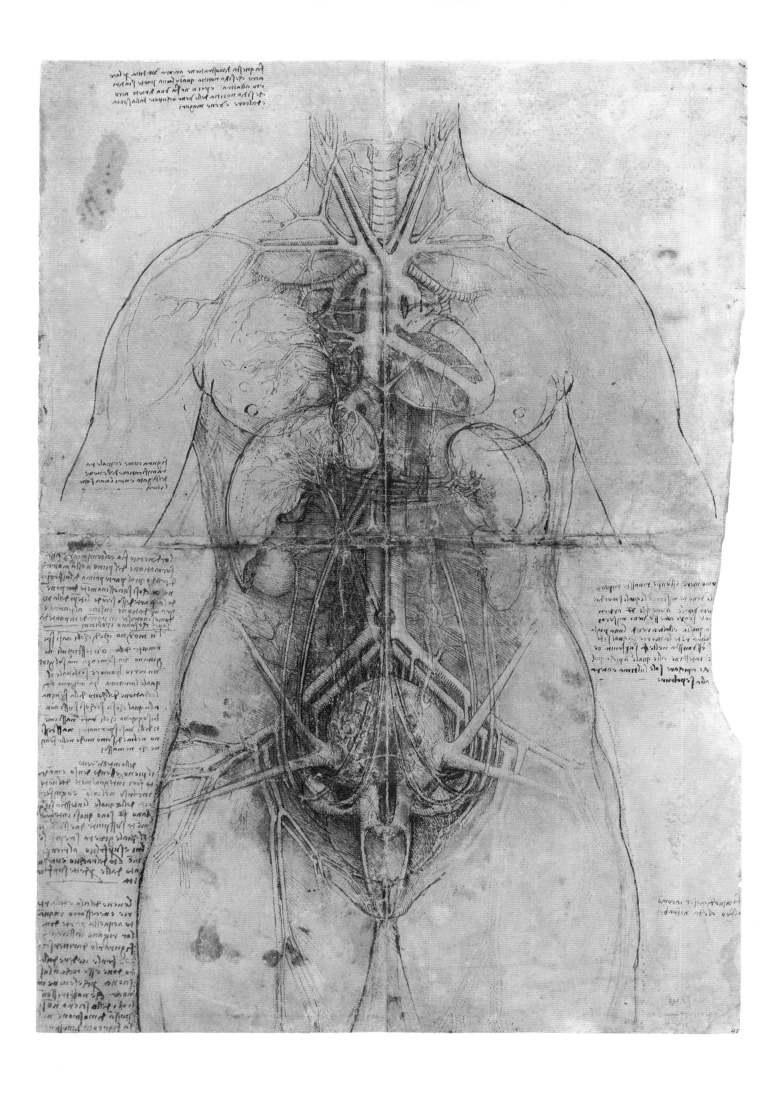

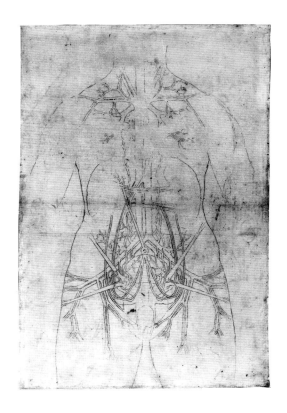

Fig. 21
Leonardo da Vinci, *The vessels of the female.* Pen and ink over charcoal pounce-marks. Windsor Castle, Royal Library (RL 12280v).

There is no evidence that, having clarified these structures, Leonardo pursued the great female situs any further. A note at the top of the sheet reads, "Make this demonstration seen also from the side in order that knowledge may be given as to how much one part is behind another, and then make one from behind in order that knowledge of the vessels located near the spine and heart and great vessels may be given." Like so many of his memoranda, this probably came to nothing.

As Leonardo's knowledge of the viscera grew in sophistication, the possibility of representing the entire internal structure in a single diagram must have seemed increasingly remote, despite his holistic impulses. Within a year or so, the synthetic approach was to be discarded altogether, in favor of a direct, analytic approach which made the situs figure a conceptual impossibility. The present sheet may be regarded as the swan song of that medieval tradition.

— M.C.

THIS DRAWING WAS prepared by Leonardo to be a situs figure to indicate the general location of the viscera. Even though little on the drawing is correct, it was drawn after Leonardo had anatomized human cadavers. The final effect is that of a quasi-mythical creature. Illustrating as it does the worst of early medical philosophy, it is only with difficulty that one can realize it was created by the artist of the next series of sheets. The trained eye can see abnormal symmetry, a two-chambered heart with the vena cava opening directly into the right ventricle, a uterus with what could be exaggerated ovarian ligaments and round ligaments appearing as twin horns, ovaries out of position, and reticulated vessels to carry blood from the uterus to the breasts for lactation. Some of the few redeeming features of the illustration are the appropriate level of the nipples and the approximately correct level for the tracheal bifurcation and umbilicus. The rest is myth.

— R.P.

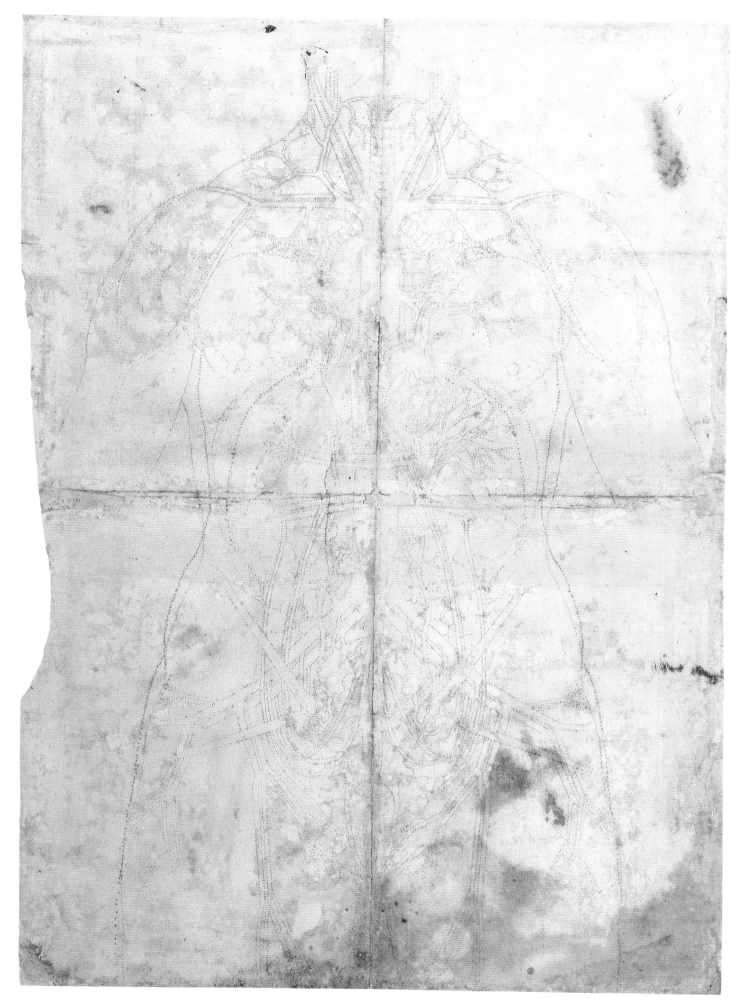

12B.

PART THREE
1510–1513

ORDER OF THE BOOK

This, my configuration of the human body, will be demonstrated to you just as if you had the natural man before you. The reason is that if you want to know thoroughly the anatomical parts of man, you must either turn him or your eye in order to examine him from different aspects, from below, from above, and from the sides, turning him round and investigating the origin of each part. But you must understand that such knowledge will not leave you satisfied, on account of the very great confusion which results from the mix-up of membranes with veins, arteries, nerves, tendons, muscles, bones, and blood which itself dyes every part the same color . . . and you cannot attain knowledge of one without confusing and destroying the other.

Therefore it is necessary to perform more dissections; you need three to acquire full knowledge of the veins and arteries, destroying with the utmost diligence all the rest, and another three to obtain knowledge of the membranes, and three for the tendons, muscles and ligaments, three for the bones and cartilages and three for the anatomy of the bones. And three need to be made of a woman, in whom there is great mystery on account of her uterus and its fetus.

Therefore through my plan, you will come to know every part and every whole through the demonstration of three different aspects of each part, for when you have seen any part from the front, with those nerves, tendons and veins which arise from the side in front of you, the same part will be shown to you turned to its side or back, just as though you had the very same part in your hand and went on turning it round from one side to another until you had obtained full knowledge of what you want to know. And so in a similar way there will be placed before you three or four demonstrations of each part from different aspects in such a way that you will retain a true and full knowledge of all that you want to know about the configuration of man.

RL 19061r, c. 1510–11

Although Messer Leonardo can no longer paint with the sweetness which was peculiar to him, he can still design, and instruct others. This gentleman has written a treatise on anatomy, showing by illustration the members, muscles, nerves, veins, joints, intestines, and whatever else is to be discussed in the bodies of men and women, in a way that has never yet been done by anyone else. All this we have seen with our own eyes; and he said that he had dissected more than thirty bodies, both of men and women of all ages.

Report by Antonio de' Beatis of a visit of the Cardinal Luigi d'Aragona to Leonardo, at Cloux, France, October 10, 1517. Leonardo died on May 2, 1519.

13A.

THE SPINAL COLUMN

c. 1510–11
Pen and ink with wash, over traces
of black chalk, 11¼ × 7⅞ inches
(28.6 × 20.0 cm.)
RL 19007v
K & P 139v; O'M & S 2; Philo
et al. 4–8

CATALOGUE NUMBERS 13a to 16b and 18a to 21 are from the so-called Anatomical Manuscript A, a homogeneous collection of osteological and myological studies compiled over a short period of time, and datable from a note on RL 19016r to the winter of 1510–11 (see cat. 21).

Here, a highly economical use of unerring wash and a cursory pen-line give the drawings of the vertebrae such a sense of plasticity that the curvature of the column may be perceived even in the anterior view at the upper right. The articulation of the cervical vertebrae is then examined using a technique increasingly exploited by Leonardo in his later researches, that of the "exploded view."

The method of displaying the components separated, with indications of their connections, is now so familiar to us in technical diagrams that it is hard to appreciate the originality and lucidity of Leonardo's exploitation of the device throughout Anatomical Ms. A. This interest in the physical interrelationship of the components of the human body is typical of the mechanistic bias of his late studies.

Leonardo's acute sensitivity to small changes in size and shape is revealed by the parallel vertical lines on either side of the anterior view, relating the projections of each vertebra to the maximum width of the column. The exploded view renders both the nuances of form of the vertebrae and the mechanism of their articulation in a single diagram. Leonardo was fully aware of the volume of information conveyed by such clarity of illustration:

> Thus you will give true knowledge of their shapes, knowledge which is impossible for either ancient or modern writers. Nor would they ever have been able to give true knowledge without an immense, tedious and confused length of writing and time. But through this very brief way of drawing them from different aspects, one gives a full and true knowledge of them. And in order to give this benefit to men, I teach the way to reproduce it in order; and I pray you, O successors, that avarice does not constrain you to have them printed in [woodcut].

The implications of this damaged note are discussed in the introductory essay.

—M.C.

ANATOMICALLY SPEAKING, the finest works of Leonardo included in this volume begin with this sheet and end some eight sheets later on cat. 21. The subject matter of these sixteen pages is primarily osteological,

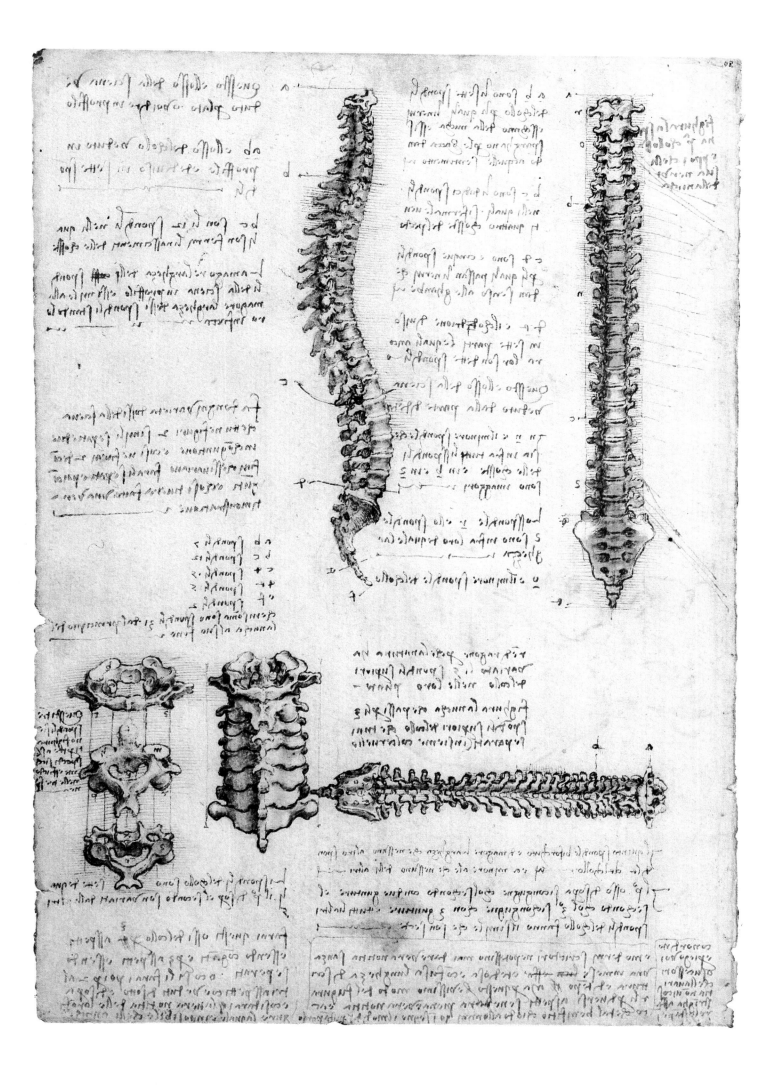

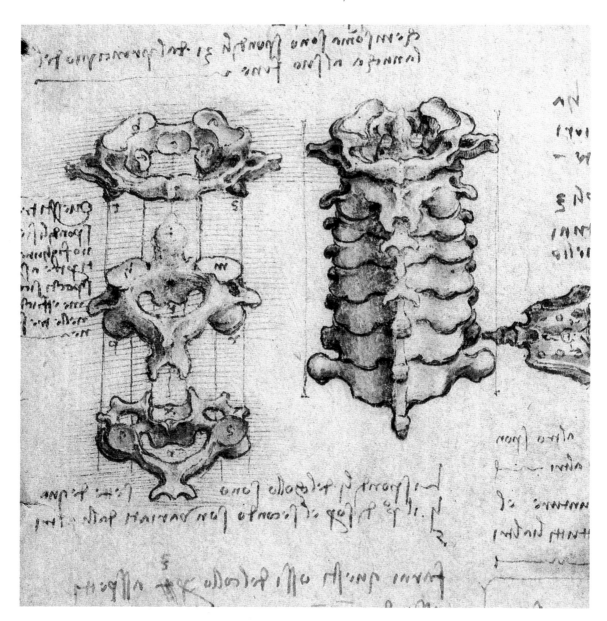

The cervical vertebrae: detail of cat. 13a.

myological, and topographical. Skeletal material was probably easier to obtain than were cadavers, while many of the muscles were visible from the surface, especially in thin individuals. Moreover, Leonardo's keen architectural mind and bioengineer's mentality could correctly interpret purpose, if not exact physiology, for the head and appendages far easier than for the viscera. Few errors exist in these sixteen pages; there are variants, however, and on some the perspective may need explanation. A vast number of structures are illustrated. Leonardo did not try to name them all and neither shall we.

While the last illustration can be criticized for having little on it that is correct, this sheet can be praised for having perhaps only one flaw, to be pointed out later. One could teach in today's medical schools with these illustrations. On this sheet Leonardo corrected centuries of confusion concerning the number of vertebrae, their relative proportions and articulations, and the shape of the assembled spine. The terminology presented is archaic, and there are far too many structures to name, but the detail is apparent. The number of segmental vertebrae is listed in the left-hand column of notes, just below center. Read them: 7, then 12, then 5, 5 again, and finally 2. Segmental names such as cervical, thoracic, lumbar, sacral, and coccygeal are missing, but vertebrae were called spondyles at the time. Leonardo has successfully recognized the differences among the segments and has missed only on the number of coccygeal vertebrae. However, we know that the number of fused coccygeal segments varies anyway. Note the fine detail of the cervical vertebrae, bottom left, and the finely illustrated differences among the first cervical vertebra or atlas, the second cervical vertebra or axis, and the third cervical vertebra—typical of the remaining five. For perhaps the first time, the sacrum is correctly represented, with no excuses or arguments, as comprising five fused segments. The physiological curvatures are properly presented—the spine was often drawn straight by others—and information contained in the notes indicates Leonardo understood the importance of the curvatures for weight bearing and posture. This knowledge was carried into his drawings of the pelvis and lower extremities, to be seen later. —R.P.

13B.

SUPERFICIAL ASPECT OF THE ARM AND SHOULDER

c. 1510–11
Pen and ink over stylus underdrawing,
with black chalk, 7⁷/₈ × 11¹/₄ inches
(20.0 × 28.6 cm.)
RL 19007r
K & P 139r; O'M & S 41

A LARGE, UNSYSTEMATIC SERIES of drawings of the superficial anatomy of the shoulder and arm is to be found scattered throughout Anatomical Ms. A (e.g., on cat. 20b). The drawings are direct descendants of the *Anghiari* series, where findings from dissections were applied to a study of the living figure (see cat. 17).

Below the two pen studies is an abortive underdrawing in black chalk, of a type which underlies most of Leonardo's more meticulous studies in Anatomical Ms. A. The sketch, of the muscles and bones of the upper arm, is close in detail to the worked-up drawings of cat. 20a.

The word *leoni*, written in the corner in a sixteenth-century hand, is possibly the name of Pompeo Leoni, the sculptor through whose hands passed all the Leonardo drawings now at Windsor. The name recurs on a companion sheet, RL 19004v, but its immediate significance is unknown.

— M.C.

SURFACE ANATOMY WAS ONE of Leonardo's many strengths, and these two studies of the shoulder musculature in an edentulous man are representative of his accomplishments.

— R.P.

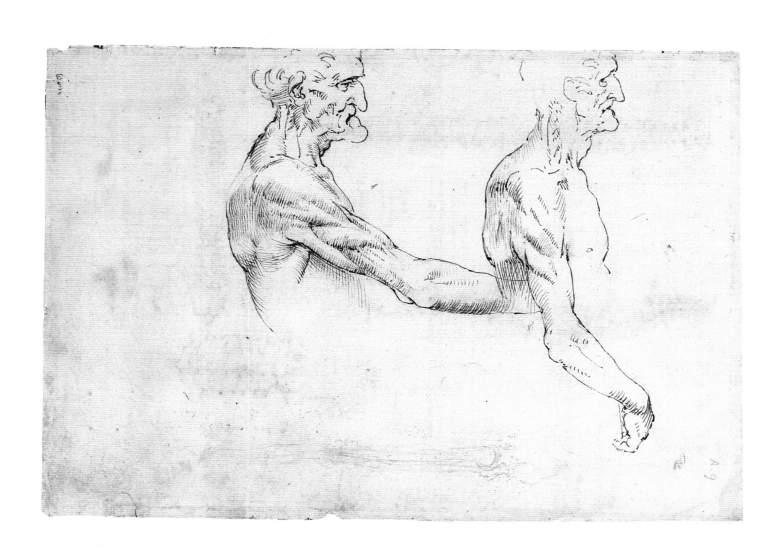

14A.

THE DEEP STRUCTURE OF THE SHOULDER

c. 1510–11
Pen and ink with wash, over traces
of black chalk, 11³/₈ × 7¹³/₁₆ inches
(28.9 × 19.8 cm.)
RL 19001r
K & P 136r; O'M & S 50; Philo et al.
101–8

THIS SHEET DISPLAYS the full range of Leonardo's illustrative techniques in Anatomical Ms. A. The synthetic, diagrammatic methods of transparency and outlining have given way to altogether more concrete demonstrations: in theory, every drawing on the sheet could be reconstructed from a human specimen or didactic model.

The upper two shoulder studies show parts set away from the mass, to clarify the relationships between underlying and superficial structures. The lower diagram displays the deepest structures pulled apart, with the muscles cut (rather than rendered transparent) where they would otherwise obscure the demonstration. The drawing at the center right is an example of Leonardo's "thread model," a technique of reducing the muscles to single cords along their central lines of force, such that the full spatial structure of an entire system can be perceived at once.

There is evidence that Leonardo actually intended to construct such a model. On RL 12619, a sheet treating the muscles of the leg in the same manner, there is the memorandum, "Make this leg in full relief [i.e., in the round], and make the cords of tempered copper, and then bend them according to their natural form. After doing this, you will be able to draw them from four sides." As usual, it is not known whether such a model was ever executed.

A later note squeezed into the right margin is an astute summary of the foundations of sixteenth-century medicine: "Strive to preserve health, in which you will be the more successful the more you keep away from physicians. For their compounds are a kind of alchemy, concerning which there exist no fewer books than there are on medicine." —M.C.

THE SUBJECT MATTER on this sheet can be divided into a well-prepared and finished series illustrating the musculature of the shoulder and a series of sketches, upper right, demonstrating the shortening of the forefoot during dorsiflexion, or the lifting of the toes and foot towards the head. Leonardo's method of depicting the force of muscle contraction in the shoulder by representing their component sections as threads or strings gives a result similar to that of a dehydrated specimen. In the different views of the shoulder presented here, there is an interesting error in the scapular attachment of the long head of the triceps. Commonly termed the origin, the scapular attachment is from the lateral margin of the scapula, below the

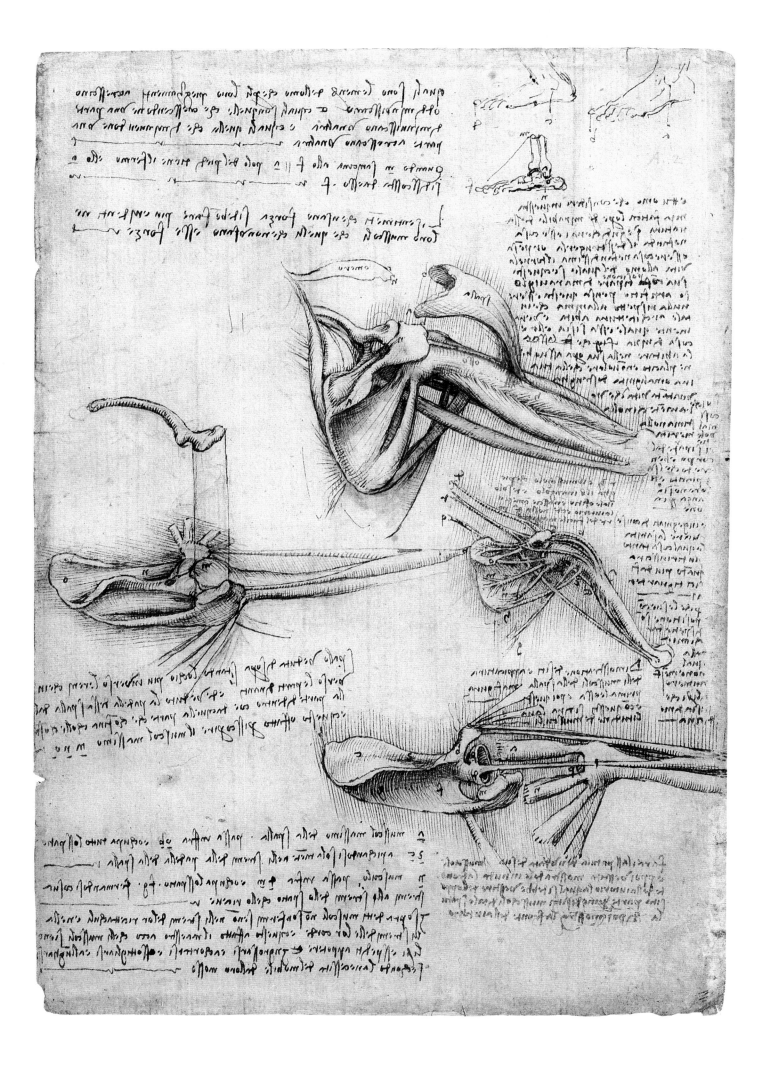

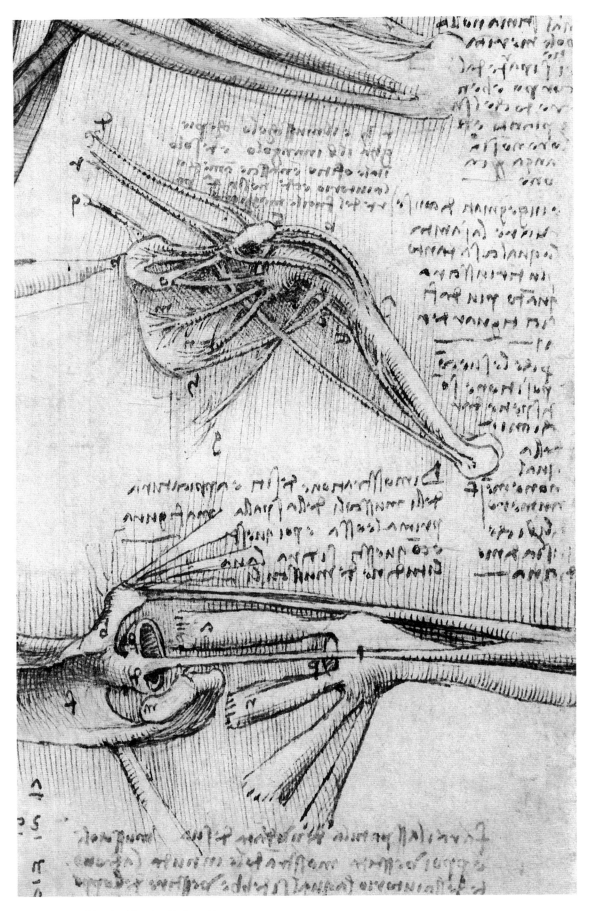

The structure of the shoulder: detail of cat. 14a.

glenoid fossa—here it is shown originating from the base of the spine of the scapula. An unusual process is shown on the acromial head of the clavicle in the illustration on the left margin. Perhaps it is only a perspective problem, or perhaps the subject had a joint disease such as arthritis.

Leonardo did not have the benefit of an accurate atlas to help him differentiate between multiple slips of the same muscle and adjacent separate muscles. Consequently, some of the muscles appear to be multiple in his drawings; an example here, in the drawing on the left margin, are the multiple slips for the attachment of the pectoralis minor muscle to the coracoid process. Even with an atlas to guide them, modern-day students continually "invent" new muscles by separating muscle bundles in this same manner. Except for the origin of the long head of the triceps, these are extremely accurate representations of the shoulder. In fact, even unlabeled, one can easily follow how the force of the muscles would be exerted and how the joints fit together.

Remember, Leonardo was of the opinion that anatomy was visual, not verbal. His credo is partly true because every word ever written in descriptive anatomy, including this entry, is an attempt to describe that which is seen with the eyes. So which is easier—visualizing the verbal, or comprehending the visual? Leonardo was close to the truth. The information not available in the visual mode includes the names of the structures and conceptual matter, such as the definition of actions and fiber content of nerves. Gross structure, however, is purely visual and that is the subject here.

—R.P.

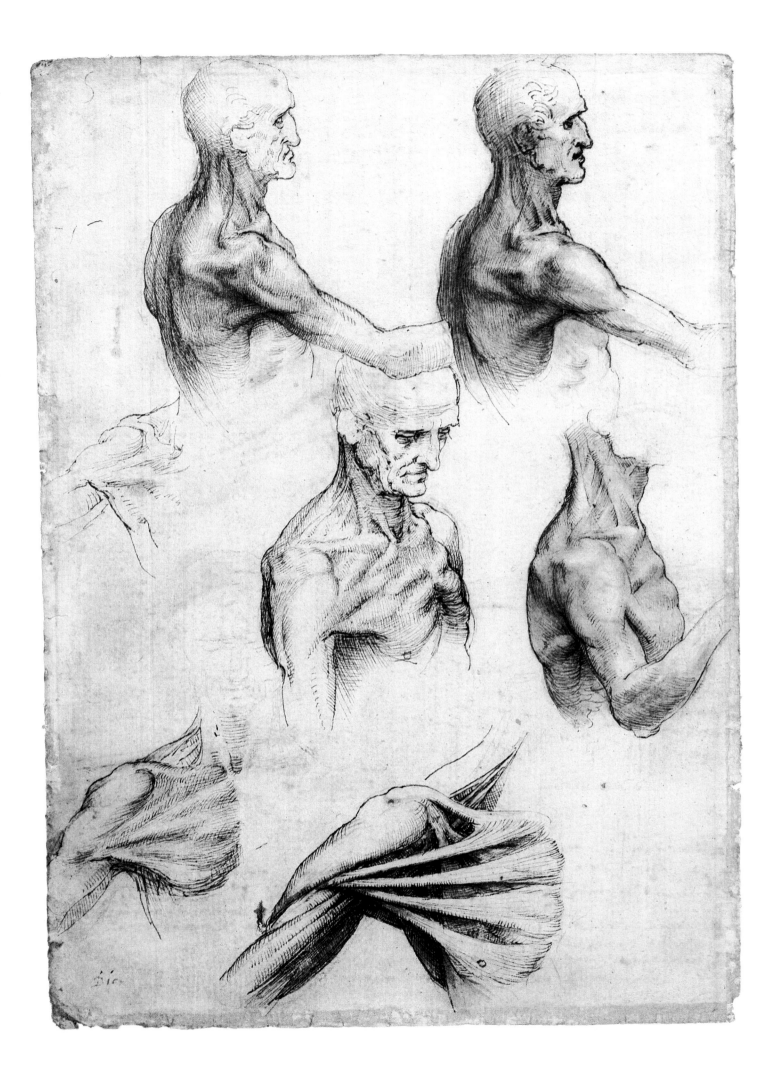

14B.

THE SUPERFICIAL ANATOMY OF THE SHOULDER

c. 1510–11
Pen and ink with wash, over traces
of black chalk, 11³/₈ × 7¹³/₁₆ inches
(28.9 × 19.8 cm.)
RL 19001v
K & P 136v; O'M & S 44; Philo et al.
65–69, 101–15

UNUSUAL IN THAT IT BEARS no commentary on its seven diagrams—compare with the profusion of notes on most other sheets from Anatomical Ms. A—this sheet may be read as the first stage of the gradual stripping-down of the shoulder, in which the superficial anatomy of an ostensibly living subject is represented. It is obvious, though, that no specific individual is depicted; the facial type is that of the "nutcracker man" who recurs throughout Leonardo's drawings.

His habit of filling pages from top to bottom and right to left (rather than the right-hander's left to right), and the differences in completeness, disguise the fact that five of the drawings form a rotated series—from an oblique posterior view, through a profile, to an anterior view at lower left. The technique was to be developed more rigorously, and much more explicitly, on cats. 15b–16a.

These drawings may usefully be compared with the underpainting for the *St. Jerome* (fig. 4), of some twenty-five years earlier, to appreciate how much Leonardo's knowledge of underlying structure had improved with his access to human dissection material in the intervening years. —M.C.

THIS SUBJECT WAS A VERY lean individual and possessed a normal variant of the pectoralis major muscle with what appear to be four separate muscles. With origins from the clavicle, sternum, and anterior thoracic wall, this muscle often presents with apparently separate bellies. Because of this, Leonardo considered the pectoralis major to be a series of separate muscles. The drawing at lower center is representative of his "fenestrations" and demonstrates the deeper pectoralis minor muscle as it attaches to the coracoid process of the scapula. —R.P.

15A.

THE MUSCLES OF THE ARM, AND THE SUPERFICIAL VESSELS

c. 1510–11
Pen and ink with wash, over traces
of black chalk and stylus underdrawing,
11³/8 × 7⁷/8 inches (28.9 × 19.9 cm.)
RL 19005r
K & P 141r; O'M & S 45; Philo et al.
115, 137; Woodburne 72, 316

DESPITE THE TENDENCY towards Leonardo's standard *vecchio*, the head at the top of the sheet is presumably that of a recently deceased subject before dissection. A strong element of idealism must, therefore, be present in the well-rounded muscles and vigorous outlines of the subsequent drawings, which are certainly not those of the gaunt man portrayed above.

In the accompanying notes, Leonardo refers to the biceps as the *pessche del braccio*, the "fish of the arm." The Latin term *pisciculus*, "little fish," was commonly used for muscles with two heads (biceps) of origin. Similar animal imagery is defined by Leonardo on RL 19014r, a study of the leg: "The muscles are of two shapes with two different names, of which the shorter is called *musscholo* ['little mouse,' which survives as the English *muscle*], and the longer is called *lacierto* ['lizard']."

The superb diagram of the superficial veins demonstrates Leonardo's full maturity as an anatomist. We are faced with a completely objective representation of material fact, and it is no hyperbole to state that modern anatomical illustration came into being during Leonardo's campaign of the winter of 1510–11. The twilight of the Middle Ages, as represented by cat. 4, has been supplanted by an entirely new spirit, a spirit which was recognized in the context of painting by Vasari when he wrote in 1568 of "the works of Leonardo da Vinci, with whom began that third manner, which we will agree to call the modern." —M.C.

NEXT TO THE DRAWING of a cadaver presumed to be the subject of the presentations on this sheet is a study of the jaw and neck viewed from below. The true significance of the small sketches at the upper right-hand corner is unknown. Beneath these sketches is a view of the right arm, thorax, and abdominal wall, with the superficial veins. This is a landmark representation. Real dissection was required to create this work. Among the veins to be seen are lateral thoracic, a small mammary plexus, thoraco-epigastrics, perforating tributaries of the internal thoracics, superficial inferior epigastrics, and possibly the superficial circumflex iliac. There is a vague line reminiscent of the termination of the great saphenous vein. This is probably the first accurate depiction of these vessels.

The lower illustration on the right side of the sheet requires some explanation. This is a study of the venous trunks of the right upper limb. The right subclavian vein joins the internal jugular vein on the far right.

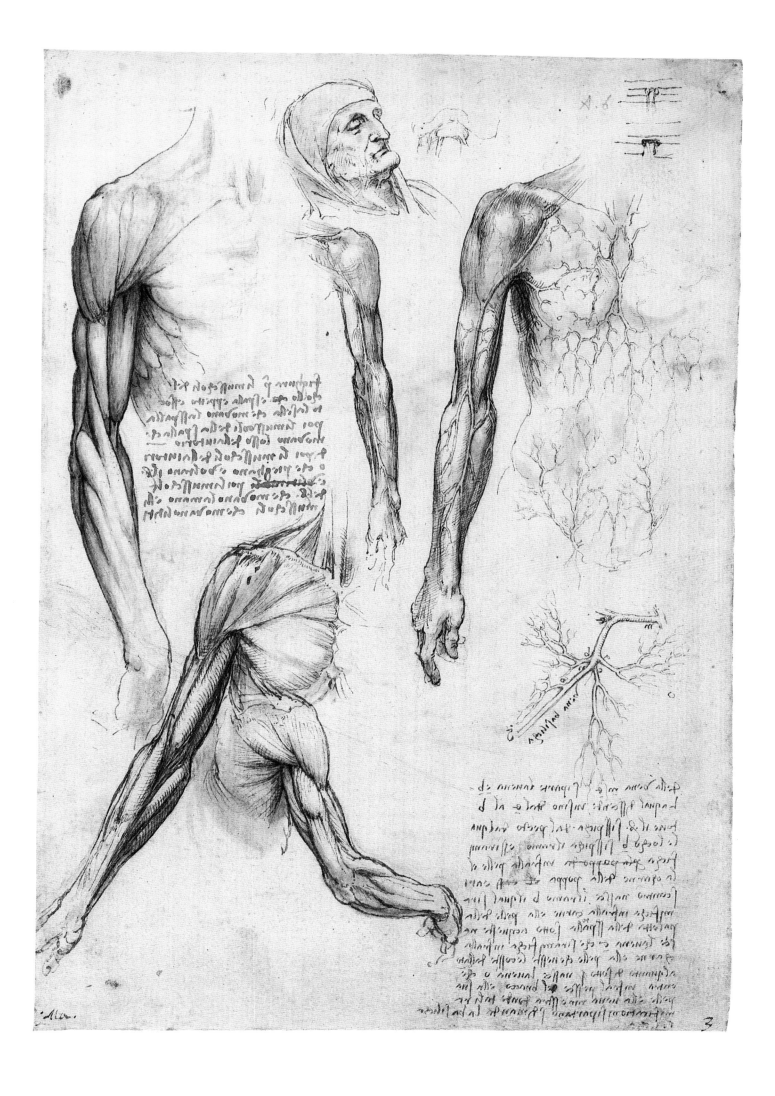

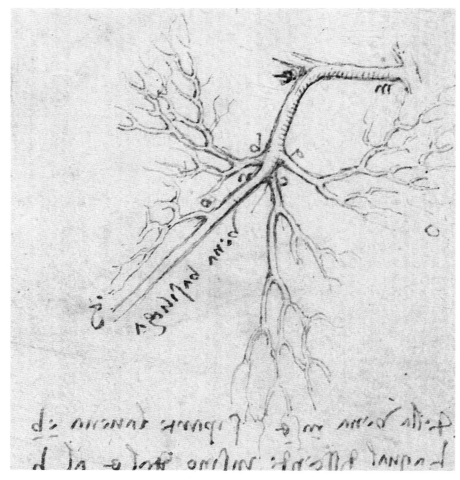

The basilic vein: detail of cat. 15a.

Trace from this point towards the left and see where the cephalic vein enters the continuation of the subclavian vein, which we term the axillary vein. Then follow the axillary vein downward to a junction with subscapular (at the left) and anterior thoracic wall branches (at the right). At that point Leonardo left the main trunk of the axillary vein and followed the basilic vein; the continuation of the axillary vein past this intersection is not drawn. He considered the pathway of the basilic vein to be the major conduit, while today we consider the axillary vein as major. In other words, we consider the basilic a tributary of the axillary, while Leonardo considered the axillary to be a tributary of the basilic. Everything is relative.　—R.P.

15B.

THE MUSCLES OF THE ARM, SHOULDER, AND NECK

c. 1510–11
Pen and ink with wash, over traces
of black chalk, 11³/₈ × 7⁷/₈ inches
(28.9 × 19.9 cm.)
RL 19005v
K & P 141v; O'M & S 47; Philo et al.
101–27

THIS SEQUENCE OF DRAWINGS must be viewed in conjunction with cat. 16a, in which Leonardo completed (or rather, with his right-to-left progression, began) the series. To give a true impression of the spatial arrangement of the shoulder muscles, Leonardo was forced to abandon his architectural surveying method of orthogonal planes. Instead, he depicted a gradual progression from anterior to posterior aspects, with an evolution of emphasis on detail as various features become more or less visible.

Michelangelo was reputed to have modeled individual muscles in wax, joining them together to give accurate three-dimensional myological demonstrations. Leonardo would have been perfectly capable of making such a model, and indeed he advocated the use of wire construction at this time (see cat. 14a). But his pains to create a sculptural effect on paper show the seriousness with which he was pursuing the idea of an illustrated treatise about 1510.

The ancient notion of continuity and infinite divisibility of aspect, position, and motion appealed strongly to Leonardo. It is implicit here in the gradual sequence of views, and in his appreciation of the shoulder as a "universal joint," as revealed at the lower left:

> Draw the arm from the shoulder to the elbow when it makes a circular movement, fixing the shoulder against the wall and moving the hand holding a piece of charcoal around the shoulder joint, keeping the arm straight. With this circular action all the movements of the muscles that move the shoulder will be made.

The note at the top of the page, clearly the first to be written, concerns the muscles of the buttocks, and has nothing to do with the content of the sheet. Such headings occur several times in Anatomical Ms. A (see, e.g., cats. 18a and 19a). They suggest that Leonardo first laid out his intended topics on the blank sheets, then as his concerns changed mercurially with the evolution of his research, he proceeded to fill them with quite different material.

—M.C.

THIS PAGE AND cat. 16a contain an inseparable series of drawings which are, anatomically speaking, to be considered a high point. There is no drawing here that would not be welcome in a modern-day anatomy text. Before the series is discussed, however, pay attention to the view of the oral cavity, oropharynx, isthmus of the fauces, and throat at the top right— remember that this is a notebook.

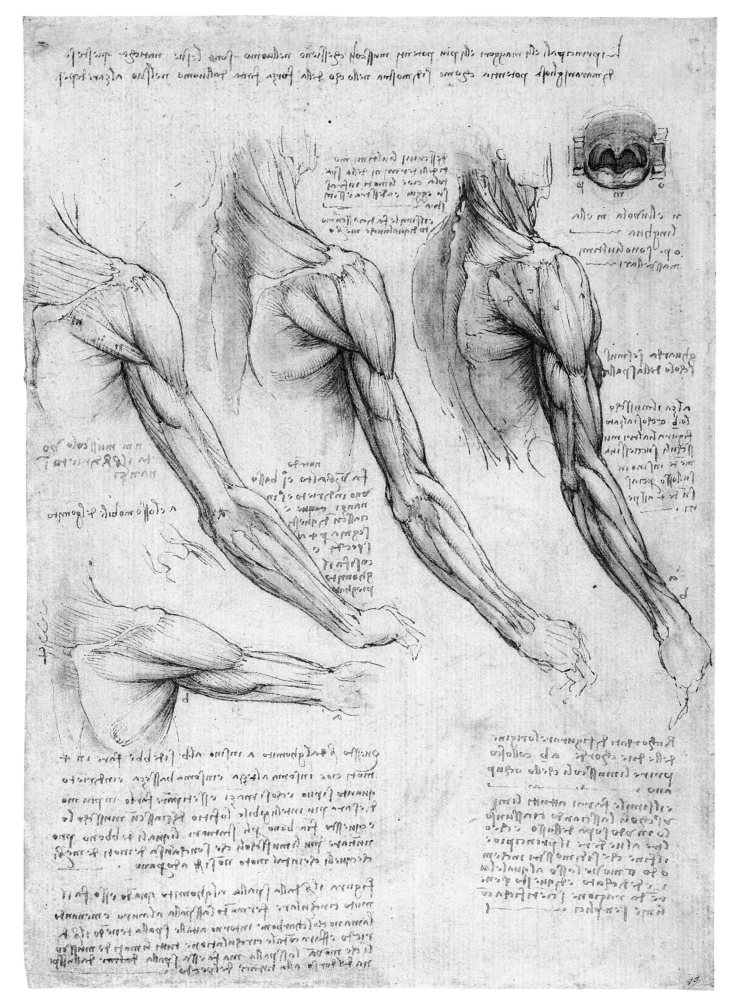

One's attention is riveted, however, to the depiction of musculature of the right upper extremity, chest, and neck which flows across the two sheets. Note how, when viewed in sequence, they become animated, as if the body twists and the limb moves down and back. These drawings are alive, the skin is transparent, the pulse can be felt. Never before equaled and never surpassed, this is at once art, science, anatomy, kinesiology, physics, and architecture—demonstrating all of Leonardo's talents utilized together. No facsimile or reproduction of this and the following image captures the pen-strokes and life of the original. If, at the end of an anatomy course, today's students could conceive in their mind's eye anatomy in the manner animated here by Leonardo, anatomists would be content. Some morphologists object to the manner in which Leonardo depicted the insertion of the deltoid, but this is truly a minor disagreement.

—R. P.

Composite image of cats. 15b and 16a.

16A.

THE MUSCLES OF THE ARM, SHOULDER, AND NECK

c. 1510–11
Pen and ink with wash, over traces of
black chalk and stylus underdrawing,
with small red chalk strokes, 11³/₈
× 7¹⁵/₁₆ inches (28.8 × 20.2 cm.)
RL 19008v
K & P 140v; O'M & S 46

AS ON THE COMPANION sheet, an initial query, "What are the veins which are confined to the bones," has no connection with the subject of the sheet, primarily a commencement of the series continued on cat. 15b.

The eight-pointed star at the lower right demonstrates the method of illustration to be used by Leonardo: "I turn an arm into eight aspects of which three are from outside, three from inside, and one from behind, and one from the front." The first three drawings follow this plan, showing an anterior, an intermediate, and a profile view, but in the continuation of the series (on cat. 15b), finer divisions are introduced, with three steps between profile and posterior views. A drawing of the "inside" is found on RL 19011v, but it does not form part of the present series.　—M.C.

THREE VIEWS OF THE posterior part of the lower neck and upper back are at the top of this sheet. In the rightmost of these views are depicted the trapezius (at right) and rhomboids (at left). In the central drawing is a muscle representative of the splenius group, and on the left drawing are muscles representative of the transversospinalis group, possibly the spinalis.

Although the muscles and motion of the upper extremity are the main focus of the central series of four drawings, one should note the exquisite rendition of the neck musculature. Two heads of the sternocleido-mastoid are visible, as well as the omohyoid muscle. Bundles representative of the anterior and middle scalene muscles, and nerves of the brachial plexus, may be indicated in the leftmost drawing.　—R.P.

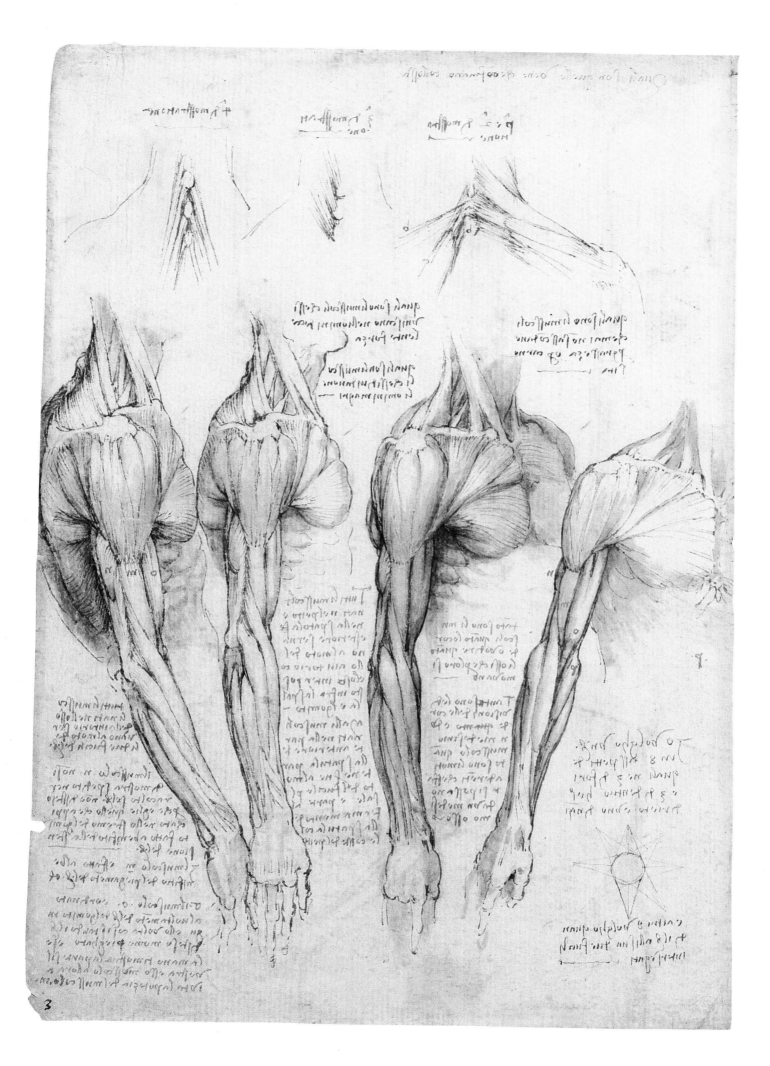

16B.

THE BONES AND MUSCLES OF THE LEG

c. 1510–11
Pen and ink with wash, over traces
of black chalk, 11³/₈ × 7¹⁵/₁₆ inches
(28.8 × 20.2 cm.)
RL 19008r
K & P 140r; O'M & S 11; Philo et al.
273, 276, 286

LEONARDO'S PRIMARY INTEREST in the mechanics of the body is
reiterated in the notes to these straightforward illustrations of the bones of
the leg. Referring to the diagram at the upper right, he wrote:

> The tendon which takes hold of the heel, pulls it upwards so much that it
> raises a man onto the ball of his foot a, the weight of the man being at the
> fulcrum b. And because the lever bc enters twice into the counter-lever ba,
> 400 pounds of force at c produces a power of 200 pounds at a, with a man
> standing on one foot.

A more sophisticated analysis is applied to the muscles of the thigh
represented by the cords of the diagrams at the upper and lower center. A
prolix note records that, when the leg is straight, the two muscles lock the
bones together; when it is bent, each has the effect of rotating the lower leg
in its respective direction, so elongating the opposing muscle.

Galen had dealt extensively with reciprocally antagonistic muscles
in his *De motu musculorum*. Though it remained unpublished until 1522, it is
reasonable to assume that Leonardo was fully aware of this work through
his contacts with the Pavian anatomist Marcantonio della Torre. —M.C.

THE ACTION OF THE MUSCLE was one of Leonardo's constant con-
cerns. He used these drawings of the bones of the lower limb not only for
illustration of the structures, but also for theorization on the actions of the
muscles which moved the bones and joints. The rope or cords on some of
the drawings are to represent direction of muscle force. A translation of the
notes indicates that Leonardo may have independently grasped the notion
of antagonistic groups of muscles, and that he was well along the way to
understanding the mechanism of motion and muscle action at the knee. The
figure on the lower left indicates what may be considered by some as exag-
gerated musculature of the hip, buttocks, thigh, and upper leg. Leonardo
may have illustrated them in this manner to distinguish between the
separate muscles. —R.P.

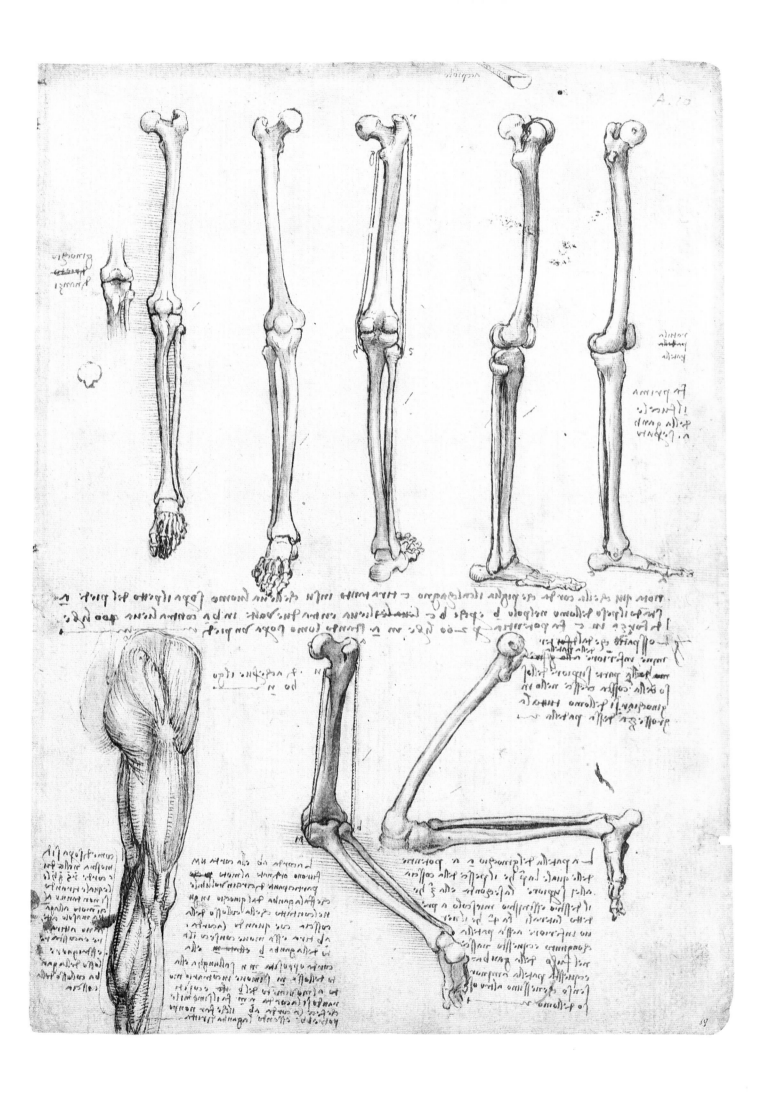

17.

THE MUSCLES AND BONES OF THE LEG AND HIP

c. 1506–7 and c. 1509
Pen and ink over red chalk, on red
prepared paper, 11¹⁄₈ × 8 inches
(28.2 × 20.4 cm.)
RL 12625r
K & P 95r; O'M & S 58; Philo
et al. 273, 276

THE PRESENT SHEET is somewhat out of chronological sequence here, interrupting as it does the flow of material from Anatomical Ms. A, but the continuity of subject with cats. 16b and 18a places it more naturally with the later drawings.

A distinctive technique of red chalk on paper coated with a red preparation (the broad brushstrokes of which are clearly visible) was commonly used by Leonardo and his studio in the years after 1500. It is typical of a series of drawings of the male musculature that he developed from the studies (e.g., fig. 9) for the *Battle of Anghiari* mural. The three myological drawings here are of this type; that at the upper right is particularly close in pose to drawings at Turin (15577 and 15630) and Windsor (RL 19043v) datable to about 1506–7.

The three osteological drawings at the lower right, however, are much more problematic. The two to the left show a comparison between the legs of a horse and of a man; Leonardo astutely noted that "to match the bone structure of the horse with that of man, make the man on tip-toe in drawing his legs." This is demonstrated in Paris Ms. K iii, f. 109v, usually dated c. 1508, but it does not necessarily follow that the present drawings are earlier (such retrospective notes are common in Leonardo's manuscripts). The more developed use of the thread convention here suggests a date nearer to Anatomical Ms. A, as do several notes that were closely echoed in those sheets. The vertebrae on the present drawings, however, are clearly more perfunctory than those on cat. 18a, and the form of the pelvis is distorted by a too-close comparison with the horse.

So the sheet appears to have been compiled in two stages, the myological drawings about 1506–7 and the osteological ones c. 1509. This phenomenon occurs throughout Leonardo's oeuvre—the cost of paper around 1500 was not inconsiderable, particularly for an artist who drew as prolifically as Leonardo, and it would be quite natural for him to fill in blank spaces on earlier sheets as the need arose. —M.C.

LEONARDO DREW THESE surface and topographical anatomical views of the lower extremity as part of a series on each region of the body. Overexaggerating the muscles to illustrate the different structures, at the lower left Leonardo has curiously rendered the gluteus maximus as almost two muscles. It has been stated that Leonardo failed to note the difference between the fleshy contours of the buttocks and the muscles beneath them. The lower series of bone and "thread" drawings represents, from center to right, a horse, a man, and a fantasy hybrid of man and horse. Leonardo recognized the comparative differences between limb segments in the human and horse and stated that man would have to walk on the tips of the toes to approximate the construction of the horse hindlimb. —R.P.

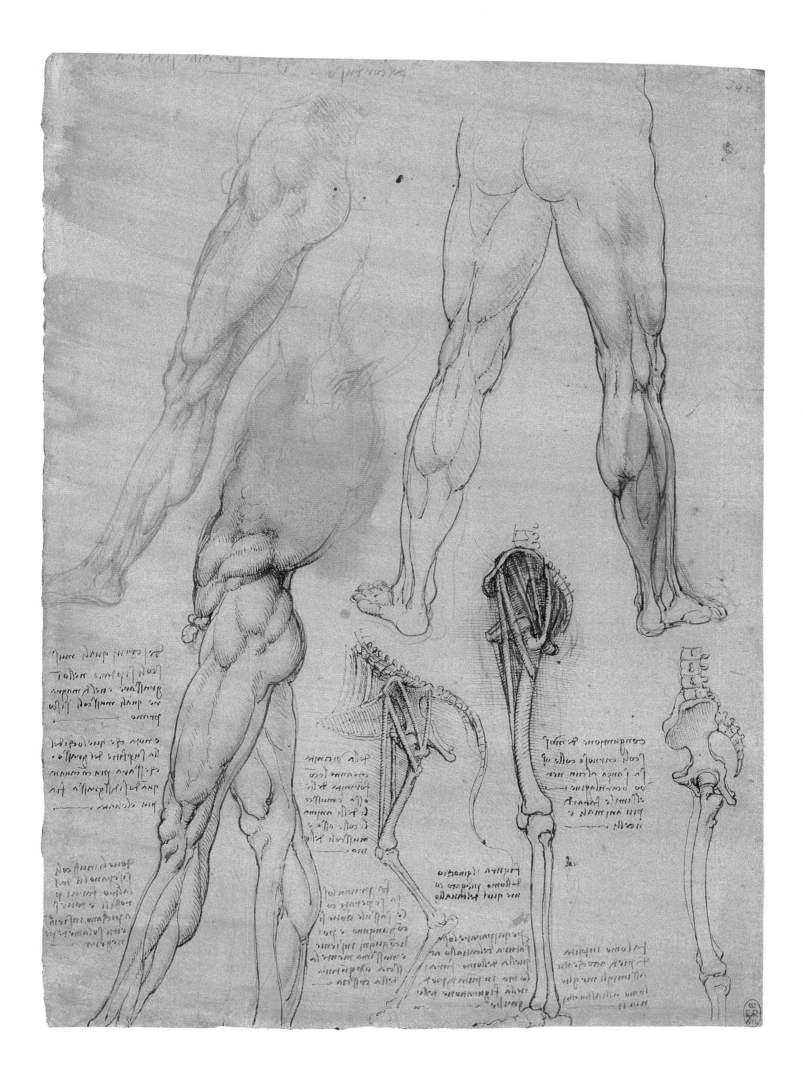

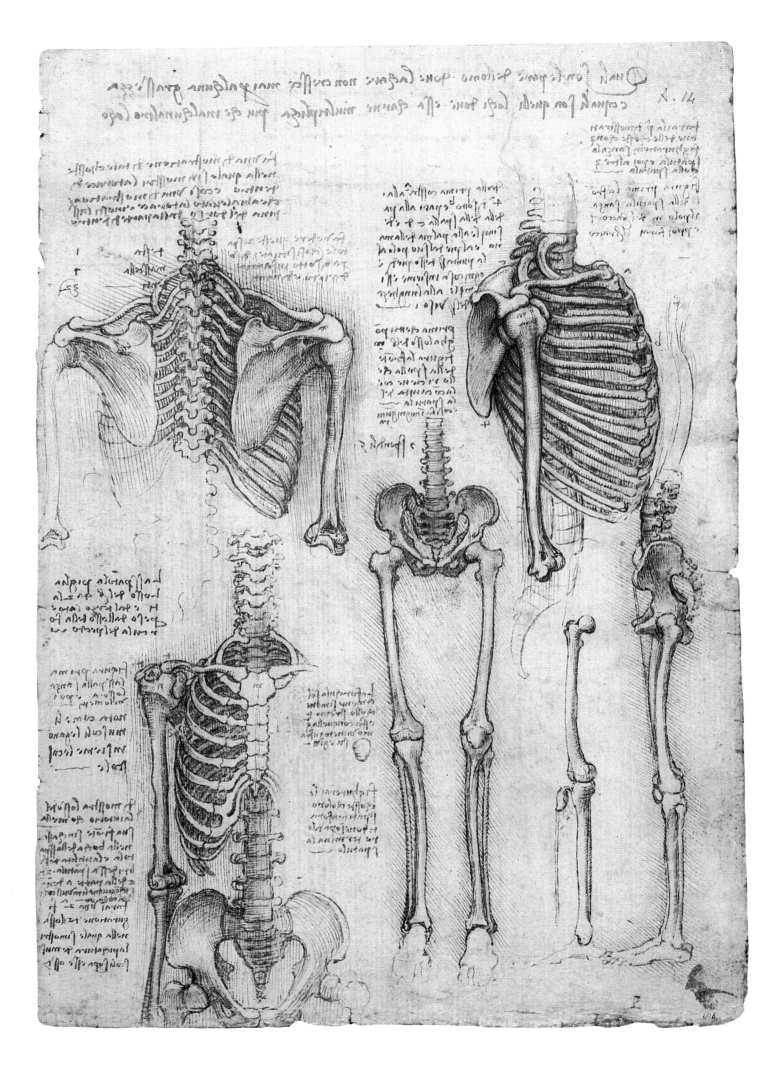

18A.

THE BONES OF THE THORAX, HIPS, AND LEGS

c. 1510–11
Pen and ink with wash, over traces
of black chalk, 11³/₈ × 7⁷/₈ inches
(28.8 × 20.0 cm.)
RL 19012r
K & P 142r; O'M & S 1

LEONARDO HERE MADE a rigorously architectural sequence of posterior, profile, and anterior views of the thorax. His evocation of three dimensionality, by progressively darkening those parts of the subject further from the observer's eye, is shown to great effect in the diagram at the lower left; the subtle use of vertical background hatching dissolves the plane of the paper to create a sculptural effect as strong as that on cats. 15b–16a.

The drawings at the lower right, which receive no comment on this sheet, are essentially a continuation of cat. 16b, although here they concentrate on the function of the patella as a sesamoid bone, a topic fully discussed on cat. 20b. They were clearly fitted around the thoracic drawings, and do not reflect any attempt to cover the entire skeleton on a single sheet.

The earlier note at the head of the sheet reads: "What are the parts of man where the flesh does not ever increase through any fatness; and what are those places where the flesh increases more than anywhere else." Variations on this reminder occur frequently in Leonardo's notes at this time, but there are few signs that he ever investigated the problem in any depth. Dürer's *Four Books on Human Proportion* (*Vier Bücher von Menschlicher Proportion*) of 1528, however, examined the proportions of figures of varying build in overwhelming detail; much work remains to be done on the connections between the two masters. —M.C.

LEONARDO UNDERSTOOD POSTURE and the implications of the physiological spinal curvatures and pelvic tilt; these are accurately and admirably shown. The angle of the first ribs is not quite right. The scapulae are too large. Two points that anatomists debated were the existence of an extra bone associated with the acromion, and of separate sternebrae, rather than a three-piece sternum. Although a separate bone at the tip of the acromion does not exist in the adult, Leonardo, a master of observation, could have observed the ununited epiphysis of a youthful acromion. With regard to the presence of the sternebrae, the sternum in humans develops in segments; separate segments can be seen in living students and colleagues, as well as in dried bones. Did Leonardo see segments to the sternum and then draw an idealized sternum? Did the nutrition of the day favor delayed closure of the separate sternebrae? Did the bones he had to study all come from the same individual? Did he have a complete skeleton? Did he ignore his own eyes and illustrate the dogma of Galen? We do not and will not know. —R.P.

18B.

THE ANATOMY OF THE FACE, ARM, AND HAND

c. 1510–11
Pen and ink with wash, over traces
of black chalk, 11³/₈ × 7⁷/₈ inches
(28.8 × 20.0 cm.)
RL 19012v
K & P 142v; O'M & S 56

THE JUMBLED CONTENT of this sheet demonstrates just how far the material of Anatomical Ms. A was from a finished treatise suitable for publication. The first notes, at the top of the page, attempt to classify the muscles according to their modes of origin and insertion; variations in ink and nib show that these alone were compiled in three stages. The remainder of the page is a patchwork of illustrations, comments, and reminders, also clearly added piecemeal over a period of time.

The hand studies are labeled as the fifth and sixth figures of the series that Leonardo began on cat. 19a, to which this sheet was originally joined. They followed the two drawings of the dissection of the face, which, though they appear to form part of a series, have no surviving counterparts. Scraps of evidence such as isolated pagination, untraceable cross-references, and so on, point to extensive lacunae in Leonardo's anatomical notes, and the present dissections may well have been carried deeper on sheets now lost.

A note that refers to the facial dissection at right reads: "Observe whether the muscle which raises the nares [nostrils] of the horse is the same as that which lies in man here at *f*." This piece of comparative anatomy was explored intuitively by Leonardo in a vigorous sketch associated with the *Battle of Anghiari*, c. 1504, that compared the expressions of fury of the horse, the lion, and man (fig. 22).

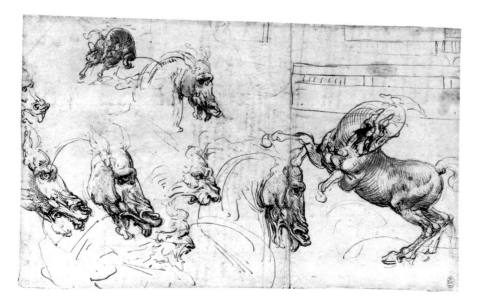

Fig. 22
Leonardo da Vinci, *Studies of horses, a lion, and a man*. Pen and ink with wash. Windsor Castle, Royal Library (RL 12326).

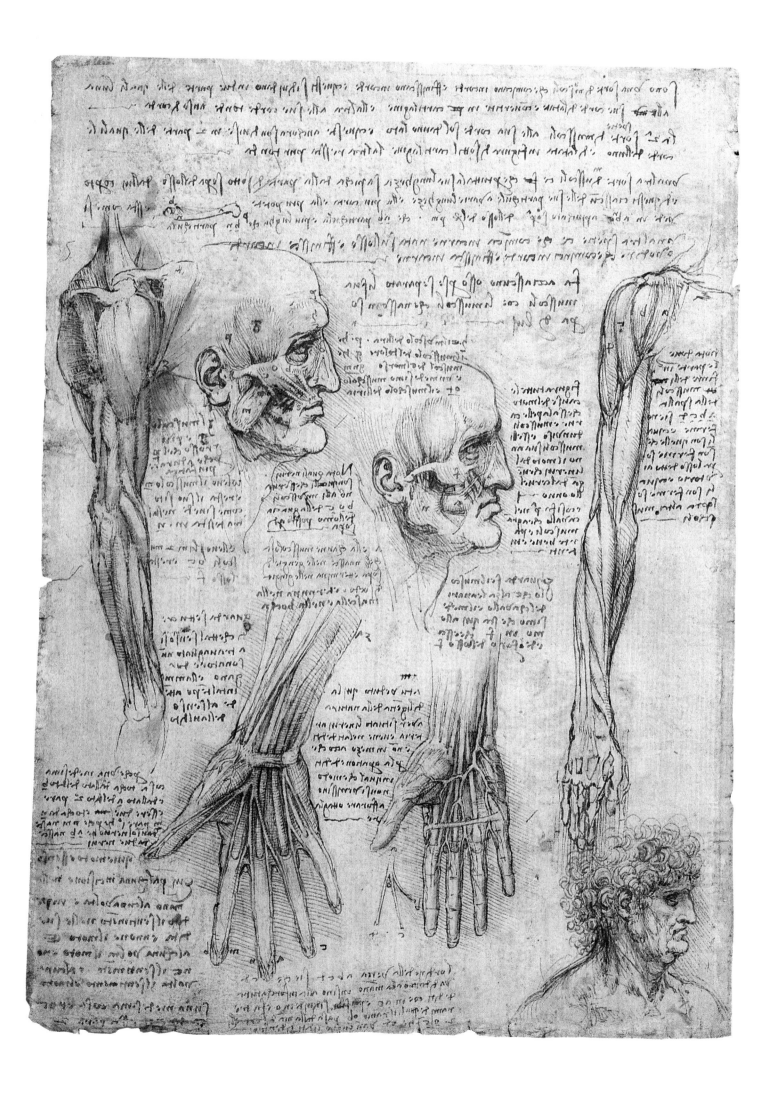

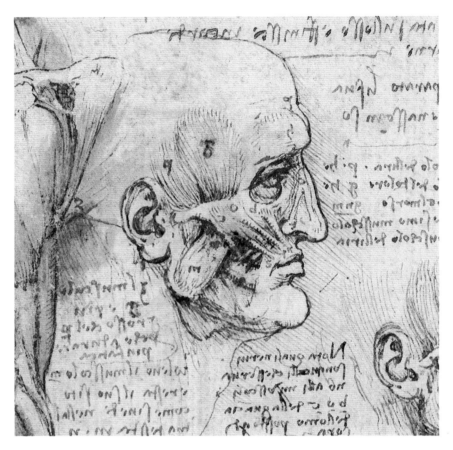

Detail of cat. 18b.

The drawings of the arm and shoulder are closely related to cats. 15a–16a, though there is no stated continuity between them. The head at the lower right is simply an elaborate doodle and has no explicit anatomical significance. —M.C.

THE VIEWS OF THE HAND on this page and on cats. 19a and 19b must be considered another high point of this selection of drawings. On this sheet, the subject of the hand is accompanied by other figures as well as some interesting notes. There are three figures of the face and neck. The upper two show remarkable dissections of the facial muscles. Because they may begin and end only in the soft tissues, not on bone, these muscles are regarded as some of the most difficult to dissect. The depictions here are accurate; the lower of the two central drawings of deeper structures depicts the buccinator muscle, among others. Two omissions are as interesting as the inclusions: where are the orbicularis oris and orbicularis oculi? It is difficult to imagine that the skill in dissection demonstrated here did not produce a clear record of these muscles. Notes at the top of the page indicate a system for naming muscles according to their appearance. In his discussion of the facial muscles, Leonardo resorted to such descriptive terms as "the muscle of pain" and "the muscle of anger."

Distribution of the median and ulnar nerves is accurately depicted in the bottom left drawing of the hand, even though the association of these two nerves with the flexor retinaculum may not be traditional. One can observe a high variant of the palmar arch in its derivation from the ulnar artery in the bottom right illustration of the hand. —R.P.

19A.

THE ANATOMY OF THE HAND

c. 1510–11
Pen and ink with wash, over traces
of black chalk, 11³/₈ × 7¹⁵/₁₆ inches
(28.8 × 20.2 cm.)
RL 19009r
K & P 143r; O'M & S 57

THIS SHEET WAS BEGUN with the celebrated but extraneous note at the head of the page: "The act of coitus, and the parts employed therein, are so repulsive that were it not for the beauty of the faces, and the adornment of the actors and their frenetic disposition, nature would lose the human species."

The page was then inverted to draw the four main figures—the first drawing is at lower left, with the upside-down note "hand seen from inside"—before being righted to add the remainder of the notes. The main diagrams are thus labeled (left to right, top to bottom) *3rd, 4th, 1st,* and *2nd,* corresponding to the fourth, fifth, first, and third demonstrations of the hand as enumerated on the verso of the sheet.

Leonardo's indecision over the better way to present the figures is resolved in a later note: "These ten demonstrations of the hand would be better turned upwards; but my first general demonstration of man obliges me to do otherwise, having had to draw him with hands down, and in order not to deviate from my principle I am persuaded to make them turned downwards."

It is apparent from the illustrations of details and the notes, mostly discussing the muscles and tendons, that the sophisticated mechanics of the hand fascinated Leonardo. The interpenetration of the flexor digitorum sublimis by profundus so impressed him that he surrounded his illustration of this, at the upper center, with the reminder: "Arrange it so that the book on the Elements of Machines . . . precedes the demonstration of the movement and force of man and of other animals, and by means of these you will be able to prove all your propositions."

The mechanistic approach is also inherent in a sequence of presentation which begins with the framework of the hand—the bones—and builds the structure by adding successive functional elements, as opposed to the dissective approach, which begins with the whole and strips it down in the natural order of a dissection.

—M.C.

IN THESE DRAWINGS we perceive Leonardo as a mature anatomist, influenced only by his own revelations. He never fully understood the actions of the lumbrical muscles, nor, perhaps, the interosseous muscles; he did not have terms for abduction and adduction; he did not understand neural transmission or muscle physiology. Nonetheless, look at what he accomplished.

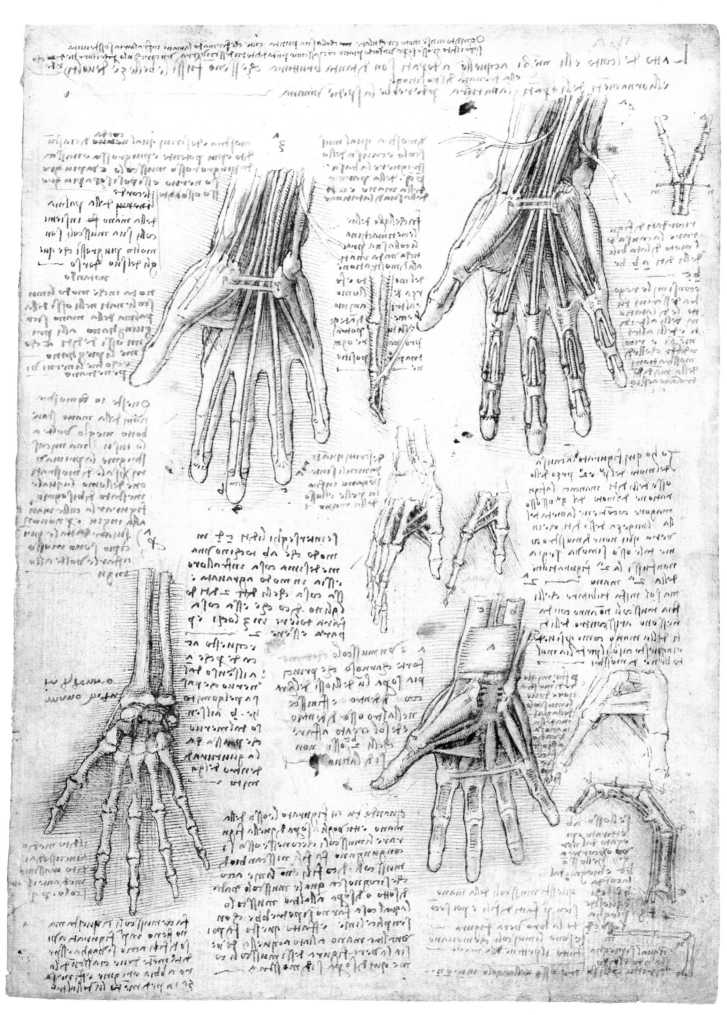

19A.

At the top left, the purpose of fibrous digital sheaths in the prevention of bowstringing of the tendons of the flexors is demonstrated. Also shown in the top series of illustrations are various heads of the adductor pollicis muscle, as well as string drawings to elaborate differences between heads of the adductor pollicis and the first dorsal interosseous muscle.

A study of the relationships of the long flexors occupies the bottom of the page. The tendon of the flexor digitorum profundus muscle is accurately depicted in passage through a bifurcation in the tendon of the flexor digitorum superficialis muscle; each tendon is properly shown proceeding to the appropriate phalange. — R.P.

19B.

THE BONES OF THE HAND

c. 1510–11
Pen and ink with wash, over traces
of black chalk, 11³/₈ × 7¹⁵/₁₆ inches
(28.8 × 20.2 cm.)
RL 19009v
K & P 143v; O'M & S 10; Philo et al.
34, 115–38

AS ON THE RECTO of this sheet, after an initial note, the sheet was inverted to draw the main illustrations (and two scored-out captions) before being righted to add the remainder of the notes and illustrations. This strongly suggests—as one might infer from the piecemeal nature of the notes—that the two sides of the sheet, and probably most of the other sheets of Anatomical Ms. A, were compiled concurrently.

A note at the head of the page details Leonardo's program of illustration of the hand, as carried out (in slightly abbreviated form) on cats. 18b–19a:

Representation of the hand
The first demonstration of the hand will be made simply of its bones. The second of the ligaments and various connections of tendons which bind them together. The third will be of the muscles which arise on these bones. The fourth will be of the first tendons which are set on these muscles and go to give movement to the tips of the fingers. The fifth will be that which shows the second stage of tendons which move all the fingers and end in the penultimate pieces of the bones of the fingers. The sixth will be that which demonstrates the nerves which give sensation to the fingers of the hand. The seventh will be that which demonstrates the veins and arteries which give nourishment and vital spirit to the fingers. The eighth and last will be the hand clothed with skin, and this will be drawn for an old man, a young man, and a little child and for each will be given the measurement of the length, thickness and breadth of each of its parts.

The two illustrations of the finger at the right of the sheet embody a return to the technique of transparency, to show all the vessels, nerves, and tendons in a single figure. The difficulties of displaying such a wealth of information simultaneously had not diminished in the year or so since the great female situs figure of cat. 12a, and it is not surprising that this brief revival of synthesis was not sustained. —M.C.

THE BONES OF THE HAND are correctly depicted for the first time. As an amusing aside, the master has accurately drawn the bones associated with the thumb: he knew that the thumb had one fewer bone than the fingers—but which was missing, a metacarpal or a phalange? Leonardo decided the metacarpal was absent and he represented the three bones as phalanges; today we feel the metacarpal is present but the number of phalanges is reduced.

Even though the central theme of this sheet is osteology, along the upper right margin is presented a study of the relationship between digital vessels and nerves to the phalanges. —R.P.

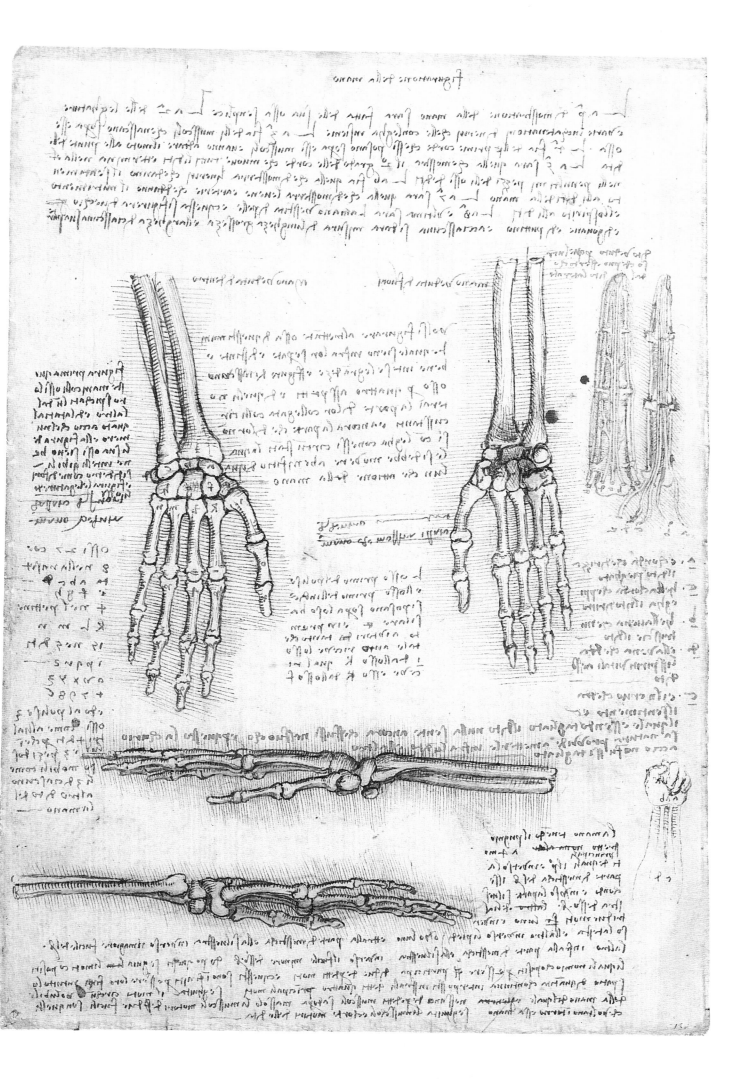

20A.

THE BONES AND MUSCLES OF THE ARM

c. 1510–11
Pen and ink with wash, over traces
of black chalk, 11¹/₂ × 7⁷/₈ inches
(29.3 × 20.1 cm.)
RL 19000v
K & P 135v; O'M & S 8; Philo
et al. 99–122

THE THEME OF THIS PAGE is the function of the biceps as a supinator, an entirely original observation not to be repeated until 1713. The action of a linear force along the length of the arm producing a rotation below the elbow must have fascinated Leonardo the engineer. It is, however, symptomatic of the tension between illustration and text, still unresolved in his anatomical work, that there is no discussion of this action in the surrounding notes.

Apparently of more interest was the shortening of the arm on pronation. The note below the fourth illustration (which shows this action) was clearly added immediately after the drawing:

The arm which has the two bones interposed between the hand and the elbow will be somewhat shorter when the palm of the hand faces the ground than when it faces the sky, when a man stands with his arm extended. And this happens because these two bones in turning the palm of the hand towards the ground become crossed . . .

The concept is clarified in the geometrical diagram at the right, where the vertical axis represents the length of the arm for various obliquities of the bones. —M.C.

THE SUBJECT OF THIS SHEET is the supination and pronation of the forearm, or, in other words, the movement of the hand from palms faced forward to backward. Leonardo concentrated upon the ability of the biceps brachii to supinate as well as flex, and upon the fact that the forearm must shorten somewhat during these two motions. He was the first to comment on either fact; however, the credit went to others. —R.P.

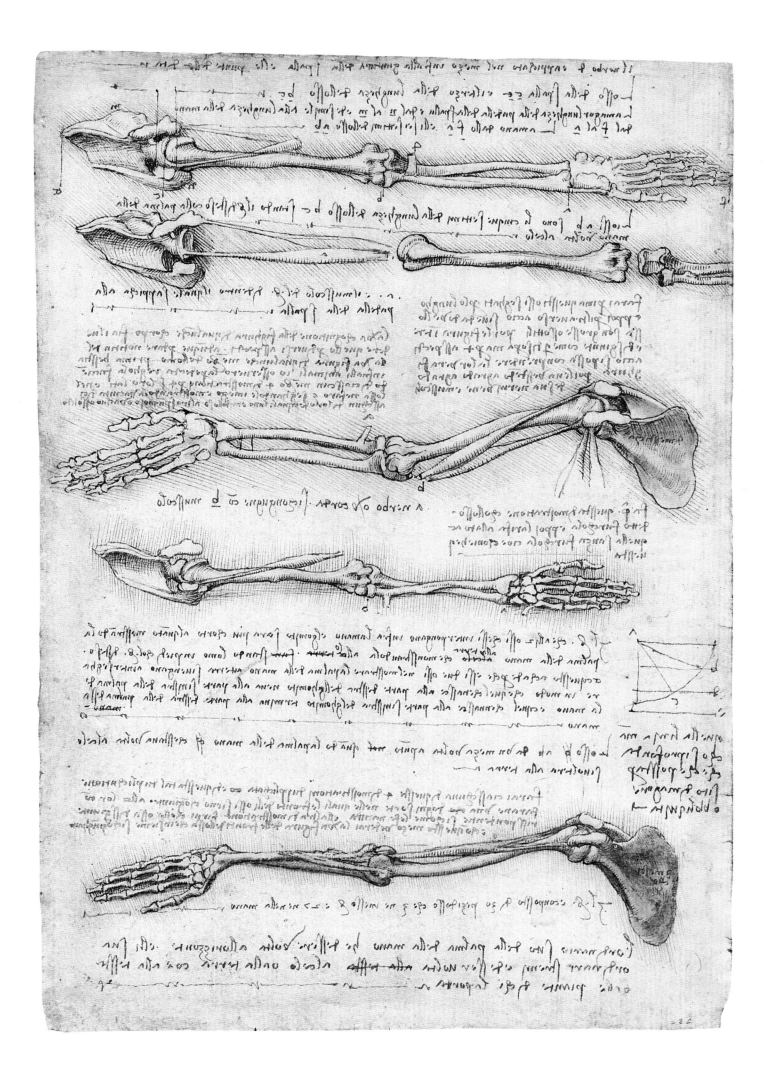

20B.

THE BONES OF THE FOOT, AND SUPERFICIAL ANATOMY OF THE SHOULDER

c. 1510–11
Pen and ink with wash, over traces
of black chalk, 11 1/2 × 7 7/8 inches
(29.3 × 20.1 cm.)
RL 19000r
K & P 135r; O'M & S 13

AFTER DRAWING THE SUPERFICIAL study of the shoulder (cf. cat. 13b) and the bones of the foot from above, Leonardo appears to have inverted the sheet to draw the plantar aspect, then adding the powerful lateral aspect, before righting the sheet to compile the notes.

The focus of attention is the function of the sesamoid bones, which are outlined with a thick nib on the central drawing, conspicuous in the lower drawing, and the subject of the accompanying notes and schematic diagrams:

> When the line of the power of movement passes through the center of the junction of moved things, these will not be mobile but will be stabilized in their primary straight line. . . . But if the line of the power of movement is outside the central line of the two rectilinear movable things, then the junction of the two . . . will make an angle at that point of contact. And . . . the farther it is from the axis of the moved bodies, the more it will bend its straightness into an angle, just as the string of the bow does.
>
> —M.C.

WITH THE EXCEPTION of another study of the shoulder, the subject matter here is the leg and the foot. A phalange is missing from the fifth digit of each bone drawing, and the skeleton of the foot is shown with no arch. With these minor exceptions, the drawings are still acceptable for use today. Leonardo recognized the presence of sesamoid bones with the tendons for the great toe, and he commented on the mechanical advantage and protection afforded by these structures. —R.P.

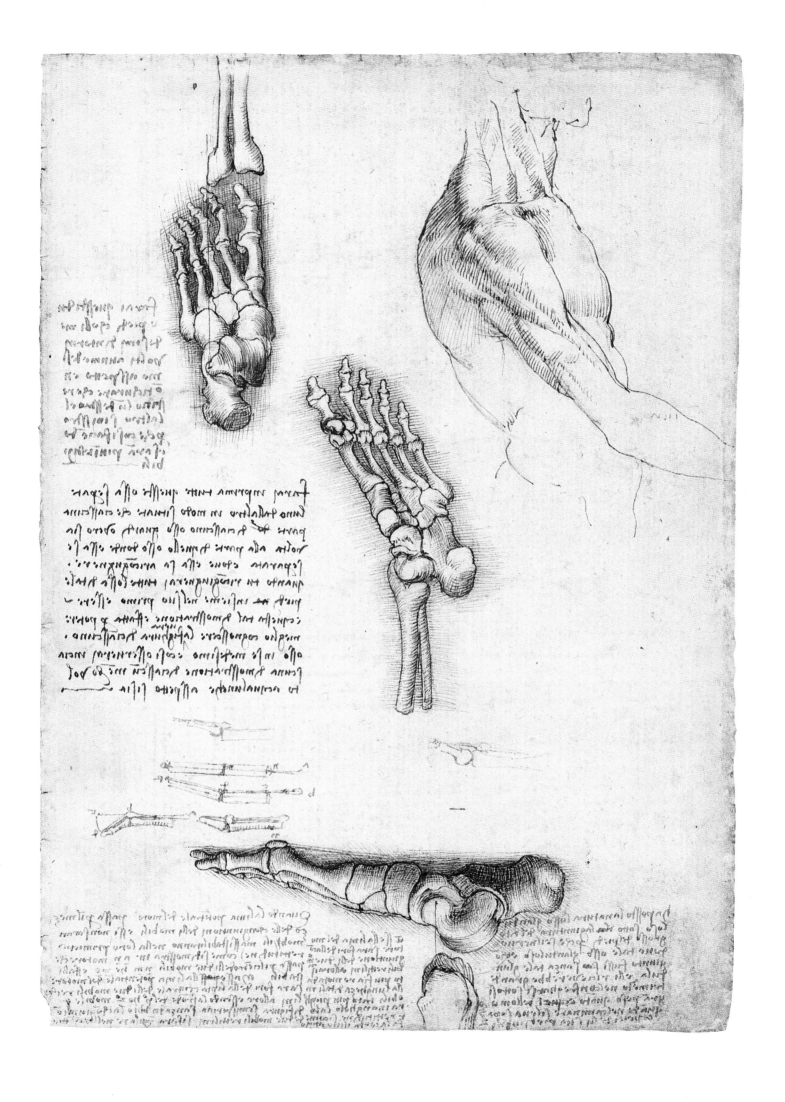

21.

THE MUSCLES OF THE LOWER LEG

1510
Pen and ink over traces of black chalk,
15³/₈ × 11¹/₈ inches (38.9 × 28.2 cm.)
RL 19017r
K & P 151r; O'M & S 74; Philo et al.
286–91

THIS SHEET IS CLOSELY RELATED to RL 19016r, which displays a
lateral aspect of the foot at the same stage of dissection and bears the note:
"And this winter of 1510 I believe I will finish all this anatomy." Both
drawings occupy a double spread of Anatomical Ms. A, and the bow-and-
arrow watermark, common to many of those sheets, is here clearly visible
across the central fold.

Unusually for the late myological studies, Leonardo uses no wash,
and the large scale of the drawing gives the regular pen-lines a hard, dis-
passionate feel. It is easy to follow the line of the tendons through to their
muscles in the lower leg, but there is no artificial accentuation of the con-
nections; only a careful alternation of modeling across the boundaries iso-
lates the muscle masses.

The extensive notes may be divided into four categories: explana-
tions of the physiology of the leg; methods of illustrating the foot and leg,
including a sequence very similar to that for the hand on cat. 19b; a descrip-
tion of muscular atrophy in the subject of one of Leonardo's dissections; and
a discussion of the nature of muscular contraction.

Leonardo took issue with the ancient theory of the pneuma, which
held that compression of air from the nerves caused both penile erection and
muscular contraction, and argued the impossibility of this purely on the
grounds of the physical properties of air. Here he offers no alternative phys-
iology, but as early as 1489 (on RL 19019v) he had correctly explained both
phenomena.

The position of relative independence into which Leonardo had
moved by this stage is shown by two notes which explicitly contradict the
authorities he had held in such esteem in earlier years. The first, "Avicenna:
the muscles which move the digits of the feet are sixty," is a relatively trivial
matter of enumeration. But the second is an involved piece of physiology:

> Mondino says that the muscles which raise the toes are in the outer side of
> the thigh, and then adds that the back of the foot has no muscles because
> Nature wished to make it light in order that it should be easy to move....
> And here experience shows that the muscles *abcd* move the second piece of
> the bones of the toes, and the muscles of the leg *rst* move the points of
> the toes.

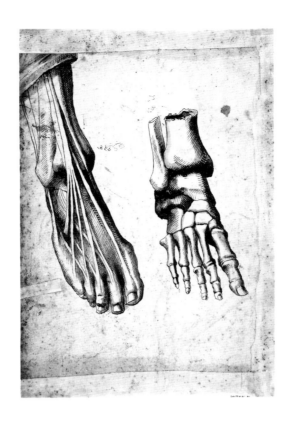

Fig. 23
Attributed to Domenico Beccafumi,
The anatomy of the foot. Pen and ink with
wash. Florence, Uffizi (10775Fv).

It should be added that the mistake was not Mondino's, but a translator's, who rendered the Latin *tibia* as the Italian for "thigh."

Finally, an intriguing drawing in the Uffizi (fig. 23) appears to replicate the pose and system of the present sheet, but in reverse, which raises the possibility that some of Leonardo's later drawings were indeed reproduced in prints. This would have had considerable implications for the spread of anatomical knowledge before Vesalius, but is unsupported by any other evidence known to the author. —M.C.

IN THIS ELEGANT DRAWING, note the detail of the extensor expansion and the correct depiction of the peroneus tertius. The extensor retinaculum has been removed. Students today could use this illustration in their studies. —R.P.

22A.

THE FETUS AND LININGS OF THE UTERUS

c. 1511–13
Pen and ink with wash, over red chalk and
traces of black chalk, 12 × 8⁵/₈ inches
(30.4 × 22.0 cm.)
RL 19102r
K & P 198r; O'M & S 210; Moore
104–22

AN INTEREST IN THE PROCESS of reproduction had been among Leonardo's first concerns in his anatomical work (e.g., cat. 3a), and culminated in a prolonged study of embryology after 1510. Apart from the 1511–13 series of heart drawings, Leonardo's late work has suffered great losses, and its extent and chronology are thus impossible to establish with any certainty.

The present sheet was compiled over a considerable period of time, perhaps several years. The memorandum at the top left reads "Book on water to Messer Marcho Ant," which quite possibly refers to Marcantonio della Torre, the Pavian anatomist who so influenced Leonardo's late work— it will be recalled that Leonardo's researches on water were frequently referred to in his investigations of the viscera around 1508–9. If so, the sheet must have been started before Marcantonio's death in 1511; yet the small sketches in pale ink are of a type found elsewhere alongside geometrical studies which may be datable to 1513–14 or even later.

The main illustration, from the early phase of the sheet's creation, makes startling use of a combination of ink and red chalk. The use of red chalk exclusively for the fetus (black chalk is used for the remainder of the underdrawing), together with the impression of compact potential so strongly reinforced by the swirling pen-work, makes the sheet one of the most emotionally affective of Leonardo's late period, far removed from the cool objectivity of the osteological and myological studies.

Although several drawings from this period deal with the viscera of the fetus, and Leonardo may well have dissected a miscarried embryo, it is clear from the subsidiary drawings that he had no knowledge of the form of the human placenta. The small sketches of the unfolding membranes, and the illustrations of cotyledons at the upper right, show that he applied his investigations of the gravid cow of cat. 9b to the human form. Accompanying notes make clear that he fully believed the structures to be the same.

The geometrical diagram at the center right, of an eccentrically weighted sphere rolling uphill, has convincingly been interpreted as a consideration of the rotation of the fetus in the womb for head-first delivery.

—M.C.

THIS DRAWING OF THE FETUS *in utero* has long been admired; unfortunately, it is flawed. Nonetheless, one can appreciate the difficulties encountered if Leonardo were to have routinely dissected cadavers of

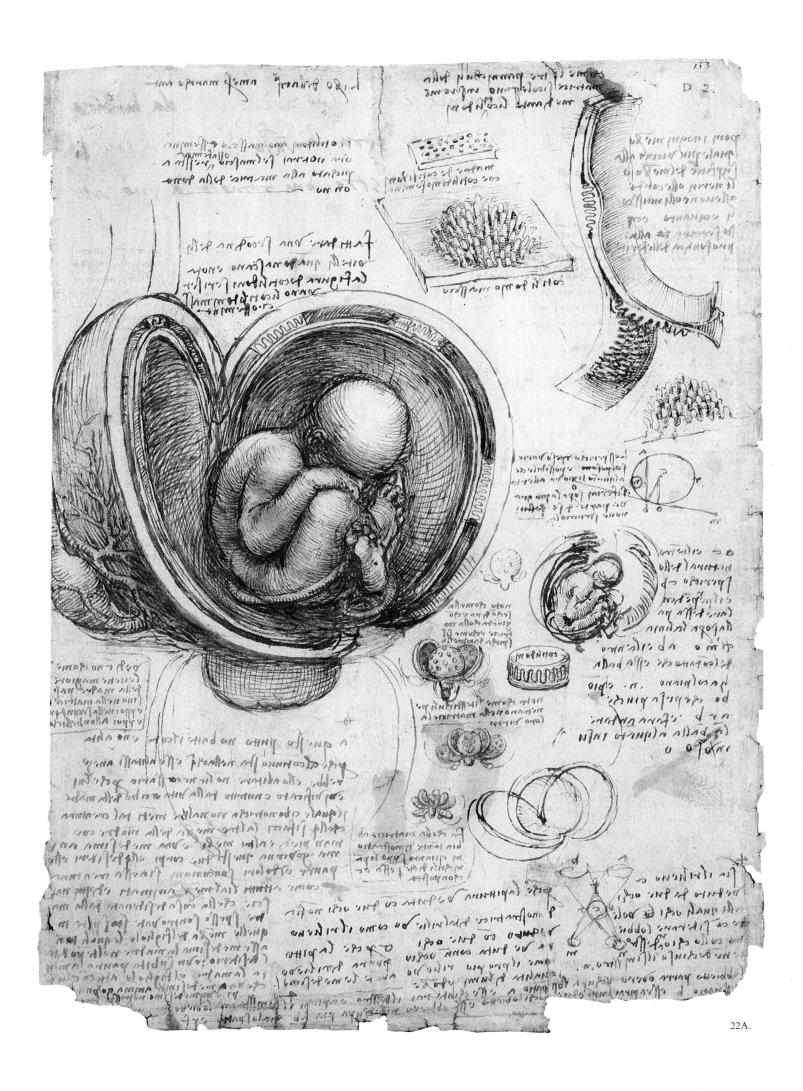

women who died in childbirth. The information presented here is derived from animal dissection, personal observations of the process of pregnancy, and the actual dissection of a fetus. Remember that Leonardo may have had no real experience with human fetal membranes; at the time of this drawing he depicted a cotyledonous placenta as in cattle, not a discoidal human one. The ovary is out of position and a mythical sperm duct is shown. Beautiful though the drawing is, its errors are great. It was, however, greatly advanced over his predecessors and contemporaries.

<div align="right">—R.P.</div>

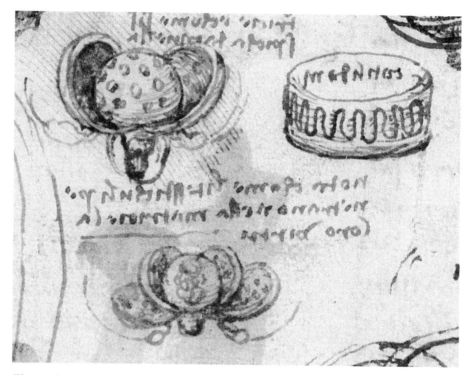

The membranes and cotyledons of the uterus: detail of cat. 22a.

22B.

EMBRYOLOGICAL STUDIES

c. 1511–13
Pen and ink, with some offset red chalk,
12 × 8⅝ inches (30.4 × 22.0 cm.)
RL 19102v
K & P 198v; O'M & S 215; Moore
38–64

THIS SHEET WAS COMPILED by three different hands. The earliest, at the top, is that of the young Francesco Melzi (who had recently entered Leonardo's studio), in two diagrams and a convoluted note on shadows which Leonardo surrounded with miscellaneous notes and figures. The note at the lower right is in an unknown hand and describes the coverings of the fetus. No member of Leonardo's studio is known to have participated in his anatomical work, and indeed his only recorded collaborator was Marcantonio. It is tempting to suggest that this note was added by the young professor himself, shortly before his death.

Most of Leonardo's text considers the evolution of the fetal viscera, in particular accounting for the asymmetry of liver and spleen. The last note to be added, squeezed in at the upper left, reads: "The black people in Ethiopia are not caused by the sun, because if a black man impregnates a black woman in Scythia [eastern Europe] she gives birth to a black child; and if a black man impregnates a white woman she gives birth to a gray child. This shows that the semen of the mother has equal power in the embryo to the semen of the father."

Thus Leonardo confirms, with material evidence, the theory inherent in the coition study of cat. 3a. —M.C.

THE SKETCHES ON THIS SHEET form a companion to another sheet (19101r) of notes and protocol on the dissection of a fetus. Included here are sketches of the viscera of the dissected fetus. The drawing at the center right margin, as well as that at the upper left, are of the embryo and its associated membranes; they suggest, but certainly do not prove, that Leonardo may have seen early aborted embryos from four to six weeks after conception. —R.P.

e nella ombra primitiua cō sera (a) circundato da luminoso
magior che suo corpo umbroso sera di p̄ato di minore figura
...ato il suo corpo umbroso sera piu remoto da suo corpo
umbroso.

23A.

THE HEART

c. 1512–13
Pen and ink on blue paper, 11³/₈ ×
17⁷/₈ inches (28.8 × 41.3 cm.)
RL 19073–4v
K & P 166v; O'M & S 86–87; Philo
et al. 162–75; Woodburne 321–40

LEONARDO'S LAST EXTENSIVE investigation which has survived is a series of drawings of the heart and rib cage, uniformly executed in pale ink on coarse blue paper. RL 19077 bears the date 9th January 1513, but the series seems to have been compiled over a considerable period of time, maybe during the couple of years before Leonardo left Milan for Rome in September 1513. Precise dating is impossible.

Only now, towards the end of Leonardo's anatomical career, does the text begin to vie with illustration for primacy. The present sheet is the most heavily illustrated of the series, and several sheets contain solid blocks of notes with only marginal sketches. Also, the relationship between word and image has changed: drawing illustrates text, and text explains drawing, with an intimacy quite different from the patchworks of cats. 13a–21.

The three-cusped valves of the heart were seen by Leonardo as a perfect example of mathematical necessity in the workings of nature. As blood was forced through the valve, eddies in the sinuses curved back into the cusps of the valve. When the flow ceased, these eddies opened the cusps against one another to form a perfect seal, preventing reflux (see fig. 11). Two cusps would not allow a sufficient aperture for flux of the blood; four cusps would be too weak in closure. Three was the optimum number, and that is what nature had provided.

The note at the upper left summarizes Leonardo's views on the beating of the heart:

> The blood is more subtilized where it is more beaten, and this percussion is made by the flux and reflux of the blood generated from the two intrinsic ventricles of the heart to the two extrinsic ventricles called auricles . . . which are dilated and receive into themselves blood driven from the intrinsic ventricles; and then they contract, returning the blood to those intrinsic ventricles.

How Leonardo continued to believe in the flux and reflux of the blood, while appreciating the perfect closure of the valves, is a mystery. —M.C.

A TRULY IMPORTANT MILESTONE in cardiac anatomy is shown on these views of the ox heart. The coronary arteries—so named because they form a corona or crown around the heart—are correctly illustrated. So, too, is the great cardiac vein and coronary sinus. Views of valves opening and

closing are depicted at the lower right corner. In addition, Leonardo apparently successfully determined that the apex, or tip, of the heart comprised the left ventricle.

In several of these views the pulmonary artery is removed at its base, thereby exposing the pulmonic valve. Thus the aorta is fully exposed and the coronary arteries are shown at their attachment to the aortic bulb. The arch of the aorta has been straightened to a vertical position and the brachiocephalic artery is correctly shown branching from the parent aorta. The remaining great vessels are pulled out of anatomical position. Unfortunately, these studies occurred late in Leonardo's life. Had he continued to question Galen and Aristotle, as well as to experiment, circulation may have been completely understood before Harvey in 1628. —R.P.

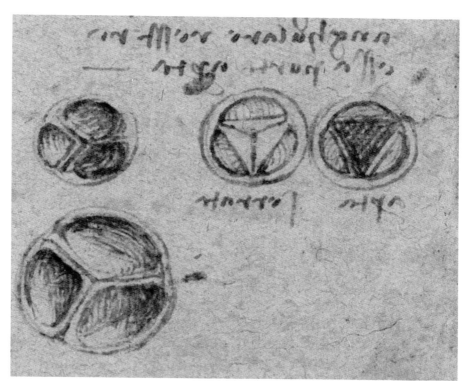

The three-cusped valves: detail of cat. 23a.

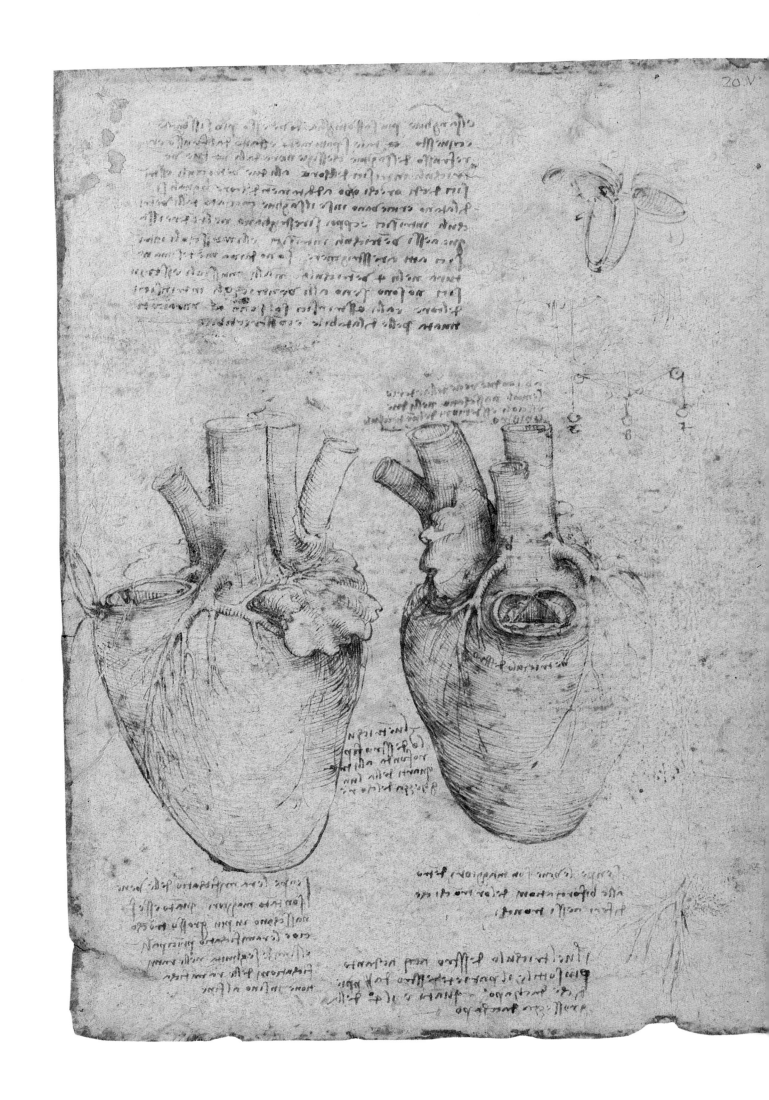

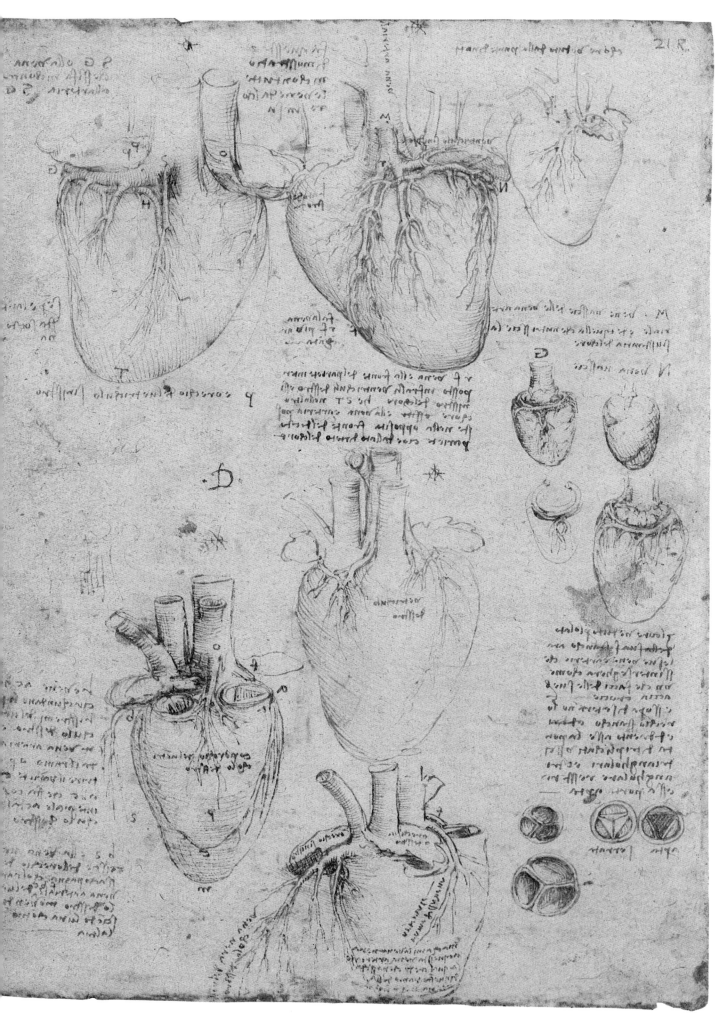

23B.

THE HEART

c. 1512–13
Pen and ink on blue paper, 11³/₈ ×
17⁷/₈ inches (28.8 × 41.3 cm.)
RL 19073–4r
K & P 166r; O'M & S 96 and 106;
Philo et al. 164–72; Woodburne 333–40

THE DRAWINGS AND NOTES to the left of the sheet describe the movements of the heart in systole and diastole, emphasizing the function of the papillary muscles in preventing excessive contraction or dilation. The faded geometrical diagram at the lower center represents a rod in stable equilibrium on a curved fulcrum; when deflected it will rock backwards and forwards in an alternate flux and reflux analogous to the motion of the heart.

Leonardo wrote of the chordae tendineae, "Nature has made the chords on the back side of the fleshy membrane of the three gates with which the gateway of the right ventricle is shut; and she has not made them on the front because these cusps feel more strain when [the ventricles] draw the blood in than when they push it out."

The slab-like diagram at the lower right is a section of the intraventricular septum, with the supposed pores illustrated, and Leonardo's comment: "The dividing wall of the heart—and thus it must be drawn in order to make it understood." Long-standing theories held that, in the process of flux and reflux, a portion of the blood "sweated" from the right to the left ventricle through the septum. In doing so it became "subtilized," providing the "vital spirit" that was distributed by the arterial system. The blood lost from the venous system was made up by the conversion of food into blood in the liver.

Leonardo never went beyond this ancient physiology of the heart. Despite his understanding of the function of the valves, the true nature of the cardiovascular system was not to be discovered until Harvey's outstanding investigations more than a century later. —M.C.

MANKIND HAS BEEN FASCINATED with the heart from the time animals became hunted—cave drawings placed the spot for the heart to aid in a fast kill. The constant beat of the heart can be felt in the chest. It was therefore natural for Leonardo to try to solve its mysteries. In this endeavor, Leonardo ignored his own credo. Although he had begun to question Galen's views on the heart and circulation, Leonardo saw the heart through the eyes of contemporary physiologists and adopted the theories of his day. Let us

not fault Leonardo too much at this point, rather we should look again at the problems facing him — the difficulty in obtaining human subject matter for dissection, no preservation for specimens, no microscope, and no concept of capillaries and circulation, of neural transmission, or of electricity. The body was governed only by physical forces: gravity, heat, tidal movements, and gases, to name a few.

Thus Leonardo never understood circulation: to him, the heart was two-chambered — the atria were stems of great vessels — and blood passed from the right ventricle to the left through pores in the ventricular septum, rather than by circulation to the lungs and back. On this page and the previous, we should be amazed by what he has accomplished in his studies of the ox heart rather than be disturbed by his lack of knowledge.

Leonardo has accurately demonstrated, on the left portion of the sheet, the difference in cross-sectional thickness of the right ventricle as compared to the left ventricle. He may have realized that the atrioventricular, aortic, and pulmonary valves lay in the same plane. On the right top he has opened the tricuspid valve and shown the papillary muscles, chordae tendineae, and valve flaps — he correctly placed the papillary muscles between cusps with chordae connected to two cusps, but incorrectly described the function of the papillary muscles. Below right center he has illustrated the closed position of the tricuspid. Along the right margin he has illustrated the closure of the tricuspid; just below the *c* one can observe a view of the closed tricuspid valve from below, with attached papillary muscles, but no ventricular wall. A foreshortened view of the ventricular chamber, papillary muscle, and chordae at the lower right center finishes the relevant illustrations. It is difficult to understand how Leonardo could so accurately comprehend heart contraction, the valves of the heart, as well as their function in the prevention of reflux, and not glimpse circulation.

—R.P.

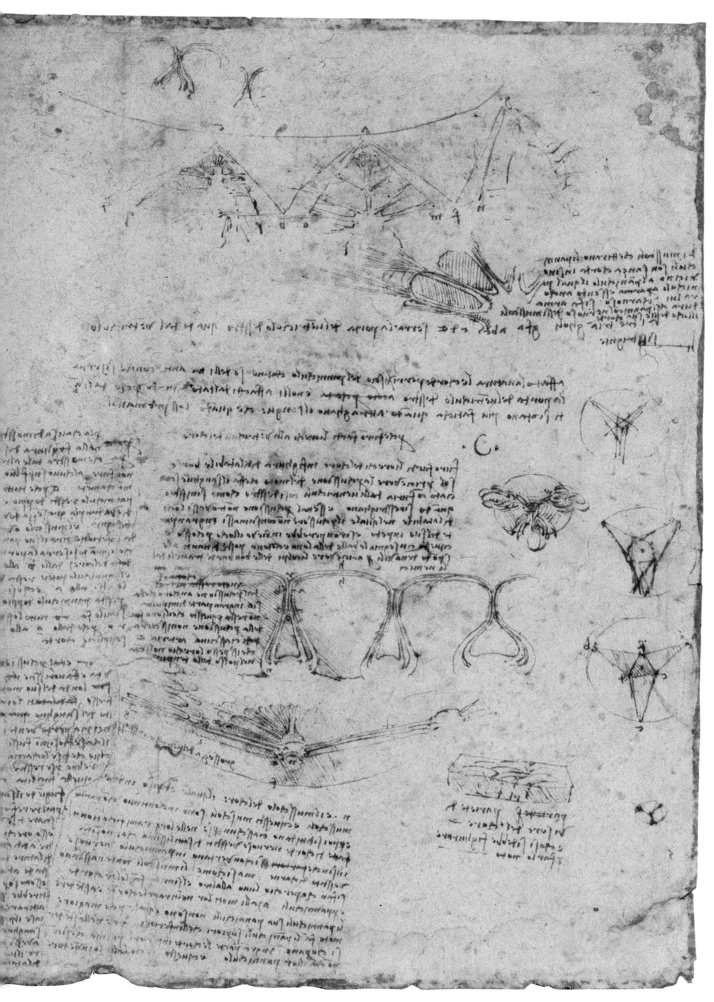

CONCORDANCES

Royal Library	Catalogue	Keele & Pedretti	Catalogue
12281	12	32	1
12597	4	35	3
12603	1	36	4
12625	17	42	2
19000	20	52	9
19001	14	53	8
19005	15	55	10
19007	13	69	5
19008	16	70	6
19009	19	73	7
19012	18	95	17
19017	21	104	11
19027	5	122	12
19028	6	135	20
19031	7	136	14
19052	10	139	13
19054	8	140	16
19055	9	141	15
19058	2	142	18
19073–4	23	143	19
19097	3	151	21
19102	22	166	23
19127	11	198	22

A NOTE ON LEONARDO'S MANUSCRIPTS

The great bulk of Leonardo's surviving writings are held in a small number of collections around the world. The scientific sheets that were separated by Pompeo Leoni from the drawings now at Windsor were bound by him into a volume known from its size as the Codex Atlanticus, now in the Ambrosiana, Milan. These sheets, referred to in the preceding pages by the abbreviation "C.A.," were first published in facsimile as *Il Codice Atlantico di Leonardo da Vinci nella Biblioteca Ambrosiana di Milano*, ed. G. Piumati (Milan: U. Hoepli, 1894–1904), 35 vols. A further twelve notebooks, the Manuscripts A–M, were looted by Napoleon from the Ambrosiana and remain today in the Institut de France in Paris. They were published in *Les Manuscrits de Léonard de Vinci*, ed. C. Ravaisson-Mollien (Paris: A. Quantin, 1881–91), 6 vols., and are referred to here as "Paris Ms." and the appropriate letter.

The anatomical sheets at Windsor were first published in a series of volumes around the turn of the century, when they were grouped under the somewhat misleading titles of Anatomical Manuscripts A, B, and C (I–VI). The abbreviations "Anatomical Ms. A" and "Anatomical Ms. B" are retained here, as those sheets were compiled in codex form, but all the anatomical sheets are now available in facsimile (see "K & P" in the following bibliography).

Further manuscripts are preserved in London (British Library and Victoria and Albert Museum), Madrid (Biblioteca Nacional), Milan (Biblioteca Trivulziana), Turin (Biblioteca Reale), and Los Angeles (Armand Hammer Collection). Several anthologies of Leonardo's writings have been published, the most useful of which remains Richter's (see the next page), which should be read in conjunction with C. Pedretti, . . . *A Commentary to Jean Paul Richter's Edition* (Oxford: Phaidon, 1977).

ABBREVIATIONS AND SELECTED BIBLIOGRAPHY

	Keele, K. *Leonardo da Vinci on the Movements of the Heart and Blood*. London: Harvey & Blythe Ltd., 1952.
	Keele, K. *Leonardo da Vinci's Elements of the Science of Man*. New York and London: Academic Press, 1983.
K & P	Keele, K., and C. Pedretti. *Leonardo da Vinci: Corpus of the Anatomical Studies in the Collection of Her Majesty The Queen at Windsor Castle*. 2 vols. and facsimiles. London and New York: Johnson Reprint Co., 1979.
	Kemp, M. "*Il concetto dell'anima* in Leonardo's Early Skull Studies." *Journal of the Warburg and Courtauld Institutes* 34 (1971): 115–34.
	Kemp, M. "Dissection & Divinity in Leonardo's Late Anatomies." *Journal of the Warburg and Courtauld Institutes* 35 (1972): 200–225.
	Kemp, M. *Leonardo da Vinci: The Marvellous Works of Nature and Man*. London: J. M. Dent & Sons Ltd., 1981.
	Mayor, A. H. *Artists and Anatomists*. New York: Artist's Limited Edition in association with the Metropolitan Museum of Art, 1984.
Moore	Moore, K. L. *The Developing Human*. 4th ed. Philadelphia: W. B. Saunders, 1988.
O'M & S	O'Malley, C. D., and J. Saunders. *Leonardo da Vinci on the Human Body*. New York: H. Schuman, 1952.
Philo et al.	Philo, R., M. S. Bosner, A. LeMaistre, J. G. Linner, and B. H. Venger. *Guide to Human Anatomy*. Philadelphia: W. B. Saunders, 1985.
	Richter, J. P. *The Literary Works of Leonardo da Vinci*. 2nd ed. London: Oxford University Press, 1939.
RL	Royal Library inventory numbers, according to which the Windsor drawings are referred in: Clark, K., and C. Pedretti. *The Drawings of Leonardo da Vinci in the Collection of Her Majesty The Queen at Windsor Castle*. 2nd ed. 3 vols. London: Phaidon, 1968–69.
	Schulz, J. B. *Art and Anatomy in Renaissance Italy*. Ann Arbor, Michigan: UMI, 1985.
Snell & Wyman	Snell, R. S., and A. C. Wyman. *An Atlas of Normal Radiographic Anatomy*. Boston: Little, Brown and Company, 1976.
	Todd, E. M. *The Neuroanatomy of Leonardo da Vinci*. Santa Barbara, California: Capra Press, 1983.
Woodburne	Woodburne, R. T. *Essentials of Human Anatomy*. 6th ed. New York: Oxford University Press, 1978.